SIGNS OF OUR TIMES

Theological Essays on Art in the Twentieth Century

For
Hallie

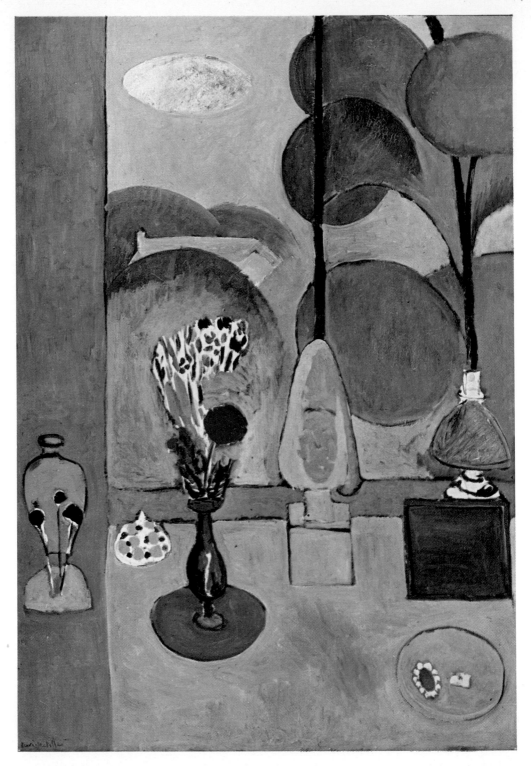

MATISSE, Henri. *The Blue Window* (1911, autumn). Oil on canvas, $51\frac{1}{2} \times 35\frac{5}{8}''$.
Collection, The Museum of Modern Art, New York. Abby Aldrich Rockefeller Fund.

SIGNS OF OUR TIMES

THEOLOGICAL ESSAYS ON ART IN THE TWENTIETH CENTURY

GEORGE S. HEYER JNR.

THE AUSTIN PRESBYTERIAN THEOLOGICAL SEMINARY

WILLIAM B. EERDMANS PUBLISHING COMPANY
Grand Rapids, Michigan

THE HANDSEL PRESS LTD
33 Montgomery Street
Edinburgh

© 1980 G. S. HEYER (Text only)

First published 1980

Library of Congress Cataloging in Publication Data

Heyer, George S
 Signs of our Times.

 These chapters comprise the Gunning lectures, which I
gave at the University of Edinburgh in 1975.
 1. Art, Modern—20th century—Addresses, essays,
lectures. I. Title.
N6490.H49 1980 709'.04 79-26805
ISBN 0-8028-1821-8

Printed in Great Britain by
R. & R. Clark Ltd, Edinburgh

CONTENTS

LIST OF PLATES

FOREWORD

THESE CHAPTERS comprise the Gunning Lectures, which I gave at the University of Edinburgh in 1975. I wish to record my deep thanks to the University and most especially to the Faculty of Divinity for their gracious invitation. In addition, the latter accorded unexampled hospitality to my wife and me, which warmed a chilly fortnight in 'Auld Reekie'. The sum of our gratitude cannot be expressed.

In the intervening months since I delivered the lectures, other works have appeared that bear upon my main theme. I have in mind books like Tom Wolfe's *The Painted Word*. None, however, has persuaded me that the arguments here elaborated and, I hope, defended, require significant revision. What I wish for this book is that it contribute to the perennial and on-going conversation between the Christian Church and the culture of which it is happily but critically a part.

<div align="right">

GEORGE S. HEYER, Jnr.
Austin, Summer, 1978

</div>

Part I

THE IDOLATRY OF ART

Chapter 1

Man the Maker of Idols

THERE RUNS through Christianity, at least in its Protestant variety, a deep strain of suspicion toward visual art. In some measure this attitude springs from our Hebrew heritage. The Old Testament is relentless in its fidelity to the Second Commandment, and the making of a graven image equals, quite simply, the construction of an idol. Such fierce rejection of images helped the Jews preserve the integrity of their own faith against the seductions of Canaanite worship. One should take care, however, not to exaggerate the uniqueness that the Jews achieved. The history of the commerce between the children of Israel and the natives of Canaan belongs to specialists, in whose company I cannot, alas, number myself. But my own colleagues in this field cite, for example, the famous fourth verse of Psalm 27, rendered in this fashion in the New English Bible: 'One thing I ask of the Lord, one thing I seek: that I may be constant in the house of the Lord all the days of my life, to gaze upon the beauty of the Lord and to seek him in his temple.' Evidence from one of the Ugaritic epics suggests a parallel to the Lord's beauty in the 'loveliness' ascribed to the goddess Anath, while additional passages both in the prophets and in the Psalms, tend to confirm the existence of such parallels in the vocabulary and ideas associated with beauty.

Intention quite commonly stumbles over circumstance, however, and we need suffer no doubts at all regarding the former. The Jews certainly meant to resist every effort to present the Lord in the form of an image. An icon could only be an idol. At the same time an idol is a very specific sort of visual image, and the Jews did not generalize from this outlook by proceeding to banish from their life all objects that please the eye. For example, they were quite prepared to make lovely 'dwelling places' for their God in the Ark and in the Temple. The *comprehensive* repudiation of images enters Christianity from another source. The notion is Greek and pre-eminently Platonic. In the Platonic hierarchy of being, precedence belongs, of course, to the Ideas, pure, eternal, and discarnate essences, intelligible to the mind alone. The sensible word, however it may exemplify, share, or participate in these Ideas, belongs, perforce, to an inferior order of being and value. Unlike the Ideas, it enjoys no permanence. Condemned to temporal flux, it shifts and alters, waxes and decays, thus leaving the human soul no solid ground on which to stand. At

best, nature furnishes man with a broken imitation of that ideal realm, toward which it is his destiny to press. Thus viewed, it may provide the occasion for his salvation, but far too often it simply tangles him in the net of alteration and so compasses his ruin. Now in this tradition art functions as an imitation of the sensible world, itself a faulty image of the eternal. Art therefore becomes a mere imitation of an imitation, and its appraisal is correspondingly debased. It provides access to reality not at second hand, but at third hand. If nature betrays man, how much more so shall its imitator, art? We know, of course, that Plato and those who followed him regarded visual art with great skepticism. It distracted man from the serious and important tasks of life and appealed to the lower elements of his nature.[1]

The followers included, for better or worse, the majority of the Fathers of the Church. We cannot recall without some amusement, I suppose, Clement's story in the *Protrepticos* of the nude statue of Aphrodite, so perfect and alluring in its form that some poor chap tried to have intercourse with it. Clement was himself not at all amused, and for us as well it is more sobering to read the strictures of an Augustine upon the delights of the senses. Augustine's biography suggests more than a passing acquaintance with these delights and their attraction, an experience that fed his ultimate and formidable reconstruction of Christian thought along Neo-Platonist lines. In such a scheme the knowledge available to the senses ranks as mere opinion alongside the lasting and certain illumination afforded by the Spirit of God. It is man's persistent temptation to let opinion do duty for illumination. Driven by an innate need for happiness, man seeks satisfaction amidst the pleasures of the senses. The quest is self-defeating, for God has created man in such fashion that his Maker alone can satisfy his desires. All else fails, and the failure will endure until man straightens out the order of his loves, until he puts in their proper place sensuous objects as instruments to use *en route* to the enjoyment of God, aids that in due course will fade and disappear before the pure contemplation of the divine essence. With this turn, this conversion, man comes to his intellectual 'senses', to to speak. His healing begins, and his restless heart now glimpses the repose that it craves. Therefore the celebrated utterance, 'Late have I loved Thee, O Beauty forever old, forever new', refers on Augustine's tongue to that beauty pleasing to the eye of the intellect alone and precisely *not* to *any* beauty pleasing to the eye of the body.

The distinction is fateful, if not also fatal. It bears tremendous import for our understanding of the creation, to say nothing of the incarnation. To these matters I shall recur in due course, as also to the question of beauty itself. Here, I wish simply to note that Augustine cemented within the main body of the Christian tradition an encompassing negative judgement upon all that gratifies the senses, including of course art and everything else that pleases the eye. On the other hand, the Church, that very practical mother of believers, usually takes without ultimate seriousness the arguments of her more intellectually gifted children. Such seems to have been her response to Augustine. In the Middle Ages, at any rate, she found astonishing scope for the visual arts and incorporated

triumphs of painting, sculpture, architecture, and stained glass into the fabric of her life. Whatever may have been their theological rationale, they answered the needs of an era and shaped its piety. Now, to us, they recall a tensionless relationship between faith and art that in all likelihood will never appear again and after which it would be futile to hanker. The Reformation, at least, not only failed to miss such a union but quite actively *dis*missed it from the realm of the Church's life.

On this score, the Reformers owe more to the Old Testament than to Augustine. Their zeal recalls the prophets, and their strictures upon images the prophetic denunciation of idols. One of the central issues concerned not so much images themselves as the role and function of the saints depicted by them. In their struggle to 'let God be God' the Reformers dismissed the saints as intercessors between God and man. Jesus Christ is the sole Mediator, whom God has provided. Recognition of this, God's sovereign act, prohibits the introduction of any further mediators. To do so burdens the relationship between the believer and his Lord, but, more to the point, it violates the sovereignty of God Himself. It offends the divine honour. With saints thus banished from the worship and piety of the Church, their images suffer the same fate.

At Zürich, Zwingli formulated a careful theology behind his rejection of images. Faith, he argued, is a purely spiritual matter; God is its unique object, whom man must trust unconditionally. As for Jesus Christ, he is indeed both divine and human, but it is by his divinity that he redeems us. Accompanying this conviction was Zwingli's marked tendency to separate the divinity and the humanity of Christ, a tendency that operates most clearly, I suppose, in his doctrine of the Lord's Supper. 'The presence of Christ at the Lord's Supper in Zürich could be only a spiritual one, for Christ could be an object of faith only and solely through his divinity. . . . As a result, the spiritual realm was sundered from the material. The faith and worship of the Medieval Church had sought to bring the two always closer and closer together. Zwingli strove to divorce them completely.'[2]

Such a viewpoint leaves little room for images, and in fact Zwingli excluded them both from the worship of the Church and from the private devotional life of believers. Men suffer from the constant temptation to construct visual images of God in their own minds, 'strange gods', as Zwingli named them. There then ensues the making of a physical image to represent the mental one, and with that an idol is created. Zwingli was willing to concede to the artist a role in the decoration of the city, but no function in the Church. His theology of the person of Christ even leads him to tolerate images of Christ in his humanity, provided these neither receive reverence nor are placed in churches. Therefore the artist may depict the figure of Jesus and episodes from his life, but to no spiritual or ecclesiastical purpose.

'We believe it wrong that God should be represented by a visible appearance, because he himself has forbidden it (Ex. 20 : 4) and it cannot be done without some defacing of his glory.'[3] These words of Calvin lay the cornerstone of his own argument against such

images. Not only images but even inscriptions are prohibited, and no justification exists for the creation of either. Calvin judges fraudulent the Roman Catholic claim that ignorant worshippers need icons for their own instruction and the stimulation of their piety. Who are these ignorant ones, he asks, if not those 'whom the Lord recognizes as his disciples, whom he honors by the revelation of his heavenly philosophy, whom he wills to be instructed in the saving mysteries of the Kingdom?'[4] Had the Church performed its duty and taught them the true doctrines of the faith, they would by no means be ignorant. The way to depict Christ, as Paul testifies in Galatians, is by the preaching of the gospel, not by the construction of images. A thousand crosses of wood, stone, or gold cannot replace the one Word of good news – that Christ died in order to reconcile us to God the Father.

The divine proscription of images restrains, in Calvin's view, man's relentless temptation to construct idols. Like Zwingli before him, he cites the human urge to bestow physical form upon the phantasies of the mind. Man 'tries to express in his work the sort of God he has inwardly conceived. Therefore the mind begets an idol; the hand gives it birth.'[5] This 'dreadful madness' afflicts the whole world, spilling into the precincts of the Church, where it erects the 'ensign of idolatry'. Human folly simply cannot check itself 'from falling headlong into superstitious rites'. This universal urge and the practice in which it issues epitomize for Calvin the sinfulness of man – his persistent, wilful desire to fashion gods of his own fancy – and the Second Commandment constitutes God's own rejection of this sin.

In at least two ways Calvin mitigates his appraisal of visual images. He tells us that he is not himself 'gripped by the superstition of thinking absolutely no images permissible'. Indeed, 'painting and sculpture are gifts of God', and Calvin seeks 'a pure and legitimate use of each, lest those things which the Lord has conferred upon us for his glory and our good be not only polluted by perverse misuse but also turned to our destruction'. While we reject all representations of God, whose majesty eye cannot see, we may yet paint or sculpt those things that the eye *can* see. Of these there are two kinds: one Calvin calls 'histories and events', the other 'images and forms of bodies without any depicting of past events'. It seems to him that the former possess a certain value for instruction or admonition. The latter, on the other hand, afford nothing 'other than pleasure'. Unhappily, most images in churches are of the latter sort, and not the slightest redeeming function can be advanced in justification of their use. On the whole, it would be better for the Church to do without images altogether. Better safe than sorry![6]

The second mitigation of his stand strikes me as very peculiarly Calvinistic. He writes: 'But even if so much danger were not threatening, when I ponder the intended use of churches, somehow or other it seems to me unworthy of their holiness for them to take on images other than those living and symbolical ones which the Lord has consecrated by his Word. I mean Baptism and the Lord's Supper, together with other rites by which our eyes must be too intensely gripped and too sharply affected to seek other images

forged by human ingenuity.'[7] To the sacraments there precedes and attaches the promise of God's Word, the matter which they signify and convey, by virtue of the presence of Christ. It is not my purpose to expound Calvin's doctrine of Word and sacrament and the ordered relationship between the two. I wish only to note that sacraments, with their visual character, belong in the Church because God himself has bound them to his Word and because from that Word alone they derive their validity. Images, like the sacraments visual in nature (but different in other ways), do not enjoy such status, for to Calvin's mind they lack this crucial relationship to God's Word. So, if the worshipper requires a visual sign, let him look not to images but instead to baptism and the Lord's Supper. *That* is where, under sensuous elements and sensuous actions, Jesus Christ fulfils his promises to his people.

At this juncture let me traverse again in summary fashion the ground that we have covered. Generally, we have been considering the Christian basis for suspicion of images. We have located one of its roots in the Jewish abhorrence of idols, enshrined in the Second Commandment, while we have found another in Augustine's criticism of *all* sensuous forms, regardless of their subject matter. We have taken note of the particular arguments adduced by Zwingli and Calvin for *their* rejection of images. While they both discern a certain restricted value in visual art, we have seen Calvin especially decry the perverse and persistent folly of man in constructing idols of his own imagining. I want now to approach this last point from a rather different side.

Let us now consider it not from the position of a theologian, but instead from that of an historian and critic of art. A number of years ago, the British scholar, Sir Herbert Read, published a book entitled *Icon and Idea*, which comprised the Charles Eliot Norton Lectures delivered at Harvard University in 1953.[8] In these lectures Read embraced a theory of symbolic forms, adopted from the philosophy of Ernst Cassirer, who argued that 'every authentic function of the human spirit', such as art, myth, or religion, expressed itself in forms peculiar to each and each of parallel rank as an expression of that spirit. While I shall speak in a later chapter of Cassirer's view of art, I intend here to concentrate on Read's own thesis, which, as he says, attempts 'to establish for the symbols of art a claim to priority which is historical. . . . For if the image always precedes the idea in the development of human consciousness, as I maintain that it does, then not only must we rewrite the history of culture but we must also reexamine the postulates of all our philosophies.'[9] Permit me to relieve the reader at once of the thought that I intend either to rewrite the history of culture or re-examine the postulates of all our philosophies! My concern is solely with Read's thesis – the priority, the historical priority of icon over idea, of image over thought.

In the course of his lectures Read considers the entire sweep of art from Paleolithic times to the mid-twentieth century. He tries to show how, in era after era, art serves as a vehicle for the extension of the human consciousness. Art is, so to say, the mind's pioneer. It moves ahead into unknown territory and gains for man his first grasp upon matters that

only later he is able to understand through ideas. The concrete adumbrates the abstract and paves the way for its advent.

The point will emerge more clearly if I furnish some illustrations of this historical process. According to Read, the earliest artists created pictures of animals that betray little if any concern for composition, to say nothing of the representation of space. The figures are linear in character, flat and two-dimensional. What they do convey, however, is an insistent vitality, a feeling of latent power residing in these primitive figures. 'The general character of this animal style of the Paleolithic period', Read argues, 'is best described by the word *vitalistic*, for the effect of the drawing, if not the intention, is to enhance the vital potency of the animals. They are usually depicted at rest, standing or lying down, with a certain monumental intensity. . . .'[10] It was only later that man isolated the concept of vitality and gauged its importance as an aesthetic principle. Because we now have firmly in mind this idea we are tempted to make the error of assigning to it historical priority. But in fact such priority belongs to the vital image, not to the idea.

Take another case – the discovery of beauty. Similar evidence exists for the prior emergence of the image. Very early there appear in such human activities as basketmaking and weaving abstract geometrical designs, a sense of form itself that precedes any articulate concept of form. In due course this sense is wedded to the one for vitality in such fashion that form is now 'applied to the representation of natural objects with incalculable consequences for the history of art'.[11] While it is true that regular geometrical figures are pleasing (and the psychological explanation is quite another matter), it is also true that they risk producing dullness and monotony. Sensitive artists recognized, as they still do, the danger and they achieved what we should now call 'asymmetrical balance', 'perpetual ease in a formal design', or, to use a striking phrase of Read, 'a "good" Gestalt'.[12] Thus was composition born and it continued for centuries as 'the essence of the work of art: art was conceived as a process of composition. But the composition, with its laws of harmony and proportion, its unity and serenity – what is it but the paradigm of that intellectual ideal which the Greeks were to call *to kalon*, and which we call beauty.'[13]

By a process similar to these there originates the idea of space, like vitality and beauty first embodied in concrete images and then subsequently formed as a concept of the mind. It thus becomes possible for man to think of space that is transcendent, as well as immanent, to think, that is, of a space inhabited by the gods, above and beyond terrestrial space. This whole development reaches its zenith in classical Greece, where the sculpture of the Parthenon frieze, of Phidias and Praxiteles, breathlessly fuses vitality, beauty and space. In this instance the ensuing conceptualization bestows philosophical word and thought upon the elements, such as line, angle, and circle, 'which had been discovered empirically by the artist . . . the quality of a straight line became straightness, and the perceived identity of shapes and pleasing divisions of lines become symmetry or harmony. Intervals of measure were identified with intervals of time, and an increasingly complex science, which we now call mathematics, became possible.'[14] Then, in an astounding closing of the circle, this

harmonic system, which sprang originally from the artist's own encounter with nature, was now read back into the natural phenomena from which it first had been derived.

I am not, I confess, satisfied with all the details of Read's argument. I think at times that I glimpse the shadow of Henri Bergson flitting in the background. Moreover, the role assigned to Jungian analytic theory leaves me unmoved. But I am content with the central thesis that Read defends regarding man's nature as a primordial and inveterate maker of images; and there is one feature of that thesis that I wish now to emphasize. It is this: the production of icons enables man to comprehend and even control nature, which, in so many of its aspects, threatens him or which, at any rate, *he* views as dangerous, mysterious, and alien. Read speaks of the 'cosmic anxiety' from which man suffers. The phrase may be too momentous but it does signify the uneasiness of the human animal face-to-face with his surroundings – and with himself! Read cites the following statement of the German philosopher of art, Conrad Fiedler: 'Artistic activity begins when man finds himself face to face with the visible world as with something immensely enigmatical. . . . In the creation of a work of art, man engages in a struggle with nature not for his physical but for his mental existence.'[15] Sanity itself depends upon the happy issue of this struggle, and man, for his identity and survival, has no choice but to enter the lists.

The need to fashion icons therefore takes its place among the most fundamental instincts of man, a veritable matter of life and death. Placed, as it is, so near the centre of human nature, and playing, as it does, so critical a role among the most basic human needs, its corrupt expression ought not surprise those who owe to John Calvin their healthy apprehension of sin! We – or at least I – owe something to Augustine as well. Man the sinner suffers from disordered loves. And the disorder is radical; it has invaded the roots of his being. God has created man in such a state that God alone can satisfy his craving for happiness. Man, however, turns away from his Maker and seeks happiness in satiation of the monstrous tapeworm of his own concupiscence. Sexual desire does not of course exhaust Augustine's definition of concupiscence, though it is its epitome. Whatever its varied forms, concupiscence is desire run amuck. It is most destructive when it gains control over those desires, like the sexual, which are most fundamental to man. At times Augustine goes so far as to argue that the compulsive nature of these desires constitutes their very sinfulness.[16] I cannot myself follow him to that extreme. But I do agree that the more basic the human need, each one in itself good and legitimate, the more disastrous its disruption. The craving for food makes of the belly a god. The desire for physical love erects a sexual idol. And now, I maintain, the need to make images issues in the idolatry of art.

The fault, of course, lies not with images. Idols do not impose themselves upon us; they are not self-creating. We, rather, are the makers of them. Calvin understood the point perfectly well when, in one of his more vivid metaphors, he describes man's nature as 'a perpetual factory of idols'.[17] I said earlier that an idol was to the Jews a particular sort of image; so it was also to Calvin – a visual representation of God or else of the saints. In

our own time, I wish to argue, this idolatry has become general. The lust that disrupts man's need to create images has spread across the entire range of visual art and the human activities surrounding it. Art as such has become an idol, the passionate focus of man's devotion. This development has not come upon us overnight. Indeed, certain sensitive students of our culture saw it approaching from afar. The following words were written over one hundred years ago:

> The uncontrolled appetite for form impels the artist to monstrous, unknown disorders. Absorbed by the fierce passion for whatever is beautiful, comic, pretty or picturesque, for there are degrees, ideas of what is right and true disappear; the frenzied passion for art is a cancer which eats up everything else. And as the definite absence of what is right and true in art is tantamount to the absence of art, the man fades away completely: excessive specialisation of a faculty ends in nothing. I can understand the rage of the iconoclasts and the Mohammedans against images. I admit all the remorse of St. Augustine for the overweening pleasure of the eyes. The danger is so great that I can forgive the suppression of the object. The folly of art is on a par with the abuse of the mind. The creation of one or other of these two supremacies begets stupidity, hardness of heart and unbounded pride and egoism.[18]

That is a statement very apt for our present day, but its unlikely author was Charles Baudelaire, who died in 1867.

Eventually I shall try to rehabilitate the reputation of art but before doing so I want to examine further the idolatry of which I have spoken. Therefore the next chapter will continue the pursuit of this theme and will concentrate upon our own century.

NOTES TO CHAPTER 1

1. Some scholars have recently argued that Plato did not take such a dim view of art. Evidence for the traditional interpretation rests upon such passages as Diotima's speech in *Symposium* 211 and Plato's remarks in *Republic* X, 595ff.
2. Charles Garside, *Zwingli and the Arts* (New Haven: Yale University Press, 1966), 177.
3. John Calvin, *Institutes of the Christian Religion*, John T. McNeill (ed.) and Ford Lewis Battles (trans.) (London: SCM Press, 1961), I. xi. 12.
4. *Ibid.*, I. xi. 7.
5. *Ibid.*, I. xi. 8.
6. *Ibid.*, I. xi. 12.
7. *Ibid.*, I. xi. 13.
8. Herbert Read, *Icon and Idea* (New York: Schocken Books, 1967).
9. *Ibid.*, 1.

10. *Ibid.*, 24.
11. *Ibid.*, 47.
12. *Ibid.*, 48.
13. *Ibid.*, 51.
14. *Ibid.*, 83.
15. *Ibid.*, 17.
16. George A. Lindbeck called my attention to this point many years ago.
17. Calvin, I. xi. 8.
18. Cited in Jacques Maritain, *Art and Scholasticism*, J. F. Scanlan (trans.) (New York: Charles Scribner's Sons, 1943), 218.

Chapter 2

Art as Society's Redeemer

THE IDOLATRY OF ART in our own time is a subject that we shall consider from two aspects. The first is that of the viewer or, one might say, art's public. One might even speak of the idolatry of the 'consumer' of art, for the term is not too crass in our present situation. The other aspect is that of the artist himself. This distinction is one that I draw for purposes of convenience and clarity; I do not intend to make it categorical. After all, these two sides of the matter bear upon one another and they are united most obviously in the concrete work of art, the object that the artist produces and that the consumer 'digests' (in one way or another).

In the early months of 1946 the Museum of Non-Objective Painting in New York (which is now the Solomon R. Guggenheim Museum, designed by Frank Lloyd Wright and located on upper Fifth Avenue) held an exhibition of pictures. It recorded in its files the reactions of a number of visitors to the exhibit, and the following is a sample of them.

It is as if the artist was God, designing and creating new worlds in His own likeness.

My visits here have become almost a religion with me. I do not understand any project before I commune with these glorious works. . . . When I come here, a strong desire to share my enjoyment with others comes over me. In a way, I do, because I am always talking about your collections, and seeing that many of the people I know come to visit this Museum.

Non-objective painting is capable of giving to man what no other kind could, the spiritual principles of the creation and organization of matter and the keys to spacial movement and rhythm, that sense of order, which the evolving human spirit needs.

The visual experience of thse profound paintings made me know with my whole being what man is and his relation to God.

I cannot express to you the ecstasy in which this afternoon has passed. You don't know how much it means to me to have found the Cathedral where my spirit can worship freely, and constantly come away newly balanced and inspired, to face my daily work.[1]

These statements possess all the features of cultic utterances. They breathe the air of religious worship before icons, whose power enables the worshipper to gain freedom, to grasp the fundamental secrets of the universe (including his relationship to God), and to pass ultimately into ecstasy. They even provoke a missionary zeal. The process that has led to this result has been developing, as I suggested in the first chapter, for a long while. Even Sir Walter Scott (if one can believe it) declared in his *Journal* that 'love of the great masters is "a religion or it is nothing." '[2] I do not propose to trace the course of this development. A summary of it may be found in a recent book by Jacques Barzun of Columbia University, entitled *The Use and Abuse of Art*. The phenomenon, however, which in the era of Scott or of Baudelaire was random and occasional, is now general and constant.

One of its clearest evidences appears in the market for works of art. The records of auction houses provide, I suppose, the soundest index to the mounting cost of art, propelled, as it is, by the public hunger for this commodity. It remains to be seen whether the economic recession in the Western World will put an end to this fervour or merely curb it for the time being. I should myself expect the latter alternative. At any rate, we have witnessed in recent years the activities of a man like Mr. Norton Simon, the American industrialist, who has expended tens of millions of dollars upon the acquisition of works of art. I am not criticizing Mr. Simon for using his gains, however gotten, in this manner; he stands in a long tradition. I cite him to illustrate the way in which our culture has draped over art a religious mantle, and Mr. Simon is himself quite explicit on the point. He recently observed: 'To me an art museum is a kind of church; a source of deep truths and spiritual experience. If a person gets the human understanding in art – gets it not just intellectually but in his unconscious and subconscious – it can have this effect.'[3] Mr. Simon conceded that one might reach the truth about life and about oneself without the assistance of art. But for him, as for countless other members of our culture, art offers the preferred path.

This *Drang nach Künsten*, as Barzun wittily labels it, is fed by our methods of communication, pervasive and efficient as they are. To be sure, exhibits of painting and sculpture travel about from place to place and, while nothing quite substitutes for the actual object of art, these exhibits remain cumbersome vehicles of communication. Reproductions, however, as well as books, journals, and mail-order courses on art suffer from no such handicap. Today, the presence of a painting is not circumscribed by the space that it occupies on the particular wall of a certain museum. It enjoys another, 'ghostly' presence, as one critic notes, multiplied thousands of times in reproductions and spread across the

map of the earth. We now witness 'a global art whose essence is precisely the absence of qualities attached to any geographical center'.[4]

Like some extinct mammal, the 'school' of art has vanished. It would never have occurred to a Sir Joshua Reynolds or a Thomas Gainsborough that he did not belong to a particular artistic school or to a group of artists bound together by a common vision and task.

Previous eras, in other words, displayed recognizable styles. But ours does not. Artists today disclaim association with any special movement. They cultivate solitude and in-wardness not because these qualities have always accompanied the creative life of the artist but rather because they serve as 'character references demanded by the reigning personalist credo'.[5] There is a style for every taste, and a taste to welcome any style. This state of affairs has evoked various responses. In the case of Barzun, for one, it is disgust, a spasm of recoil from this chaotic fracturing of the artistic universe. For this disgust he has been chided as undemocratic![6] And perhaps he is. He does see perfectly well the rise of art as a religion but he judges it by nature entirely unsuitable to play such a role, for it 'lacks a theology or even a popular mythology of its own; it has no bible, no ritual, and no sanctions for behavior'.[7] In my view he is right – and where he is right he is most wrong!

True, art does lack all these trappings of traditional religions. And *for that very reason* it is highly qualified to serve as a religion in our time. If the culture of the non-communist West manifests *any* clear characteristic, it is the renunciation of all binding modes of communal order – faith, family, state, whatever – accompanied by the perilous efforts of individuals to find human satisfaction in release from any such attachment. Art, Barzun notes, calls us only 'to enjoy but we are not enjoined'.[8] Exactly the point. It appeals precisely because it does not bind. It does not threaten modern man with the spectre of commitment; it does not tempt him to exchange for some stale servitude a fresh one. Therefore he may 'safely' enjoy art without fear of bondage to it. It is the gentlest of masters because it is no master at all. It demands no renunciation and no commitment. Moreover, among its manifold forms an individual is certain to discover one that pleases him. It may be representational or abstract. If sculpture, it may be wooden or welded, junk or stone, earth or plastic. If painting, it may be expressionistic or geometrical; it may be colour-field painting or 'raw' painting, Op art or Pop art. The choice is limitless.

In societies more tightly ordered and carefully regimented, such a choice does not exist. Several years ago the Soviet Minister of Cultural Affairs, Mrs. Yekaterina Furtseva, paid a visit to the Museum of Modern Art in New York. As it happened, the Museum had recently acquired a work of the kind judged *avant-garde* in Russia around the time of the Bolshevik Revolution. It was a painted cubist sculpture of 1913, entitled 'Symphony No. 1', by Vladimir Baranoff-Rossine. Thinking that it would interest Mrs. Furtseva, her hosts at the Museum showed it to her. It did interest her – and horrified her. 'We no longer', she declared, 'allow our artists to do things like that!'[9] More recently a group of

artists in Moscow tried to put on an outdoor exhibit of their works. The Soviet authorities broke up the show with the aid of bulldozers and dump trucks. The accounts of this latter incident lend a certain pathos to it, since the pictures explored artistic idioms that have long since been exhausted in the West. And, be it said, the show did proceed some days later under the careful eyes of the authorities. Nevertheless, the Russians perfectly well appreciate the point that free artistic expression erodes human commitment to institutions, and the state must not tolerate such a challenge to its title to full allegiance. Art, so people now believe, supplies an avenue to release, a religion without ties and thus a religion unexampled in our history. And what of the artist himself? He represents, in the words of one scholar, 'what we are trying to become, the shape we are trying to take in our effort to escape the pressures of time-worn inwardness while also escaping the bondage of new internalities. It is for his professional effort at unfixed externalizations, valid first to his own psychological economy, that the modern artist has been handed a spiritual preceptorship.'[10]

Perhaps that is only a fancy way of saying that many people now favour the 'Bohemian' style of life long ago adopted by artists. But I should not like to leave the matter there. Let us now examine the idolatry of art, not from the side of the public, but rather from that of the artist himself and his own work. In order to do so, we must retreat in time to the years that followed the First World War.

The hideous dislocations of that war administered a shock to European civilization not even equalled, I think, by the Second World War. Europe was left stunned, exhausted, and disillusioned. Wrote the American critic, Edmund Wilson, 'In our post-War world of shattered institutions, strained nerves and bankrupt ideals, life no longer seems serious or coherent – we have no belief in the things we do and consequently we have no heart for them'.[11] To some artists, the vacuity of life signalled the need to sweep away all previous artistic canons and conventions. It was to this task of destruction that the Dadaist artists applied themselves, producing works of outrageous absurdity, accompanied by manifestoes bristling with equal absurdity. It was all a game, perhaps, but a very serious and passionate game. Dada was anti-idea, anti-order, and, especially, anti-art, as art up until that time had been understood. One is able to sense the temper of the movement in these remarks by its chief publicist, Tristan Tzara.

> Sensibility is not constructed on the basis of a word; all constructions converge on perfection which is boring, the stagnant idea of a gilded swamp, a relative human product. A work of art should not be beauty in itself, for beauty is dead; it should be neither gay nor sad, neither light nor dark to rejoice or torture the individual by serving him the cakes of sacred aureoles or the sweets of a vaulted race through the atmospheres. A work of art is never beautiful by decree, objectively and for all. Hence criticism is useless, it exists only subjectively, for each man separately, without the slightest character of universality. Does anyone think he has found a psychic base common to all mankind? The attempt

of Jesus and the Bible covers with their broad benevolent wing: shit, animals, days. How can one expect to put order into the chaos that constitutes that infinite and shapeless variation: man? The principle: 'love thy neighbor' is a hypocrisy. 'Know thyself' is utopian but more acceptable, for it embraces wickedness. No pity. After the carnage we still retain the hope of a purified mankind.[12]

This outlook obviously placed very heavy stress upon subjectivity, spontaneity, individuality. Transcribed into art, it produced works with titles such as 'Bottle Rack' (an actual bottle rack), 'Gift' (a flatiron with a row of tacks attached to the bottom), or 'Fresh Widow' (a small window with painted wooden frame and, in place of glass panels, leather ones).

A silly business, of course, and an unstable one to boot, since it is difficult for artists, as well as other human beings, to make of nihilism an on-going career. What strikes me as most remarkable in the whole Dada movement is its assumption that the artist himself should undertake the attack upon the bankrupt ideals of his culture and proceed relentlessly to sweep them away. 'No pity', as Tzara wrote. And if the artist sees himself in this role he may equally well regard himself as the builder of a new culture. His task, like Jeremiah's, is to build and to plant, as well as to pluck up and destroy. In fact, many artists of the years between the wars adopted just such a constructive programme. Their art became a vehicle, consciously employed for the establishment of fresh values, new and purer modes for the ordering of human society. Not many people paused to wonder whether or not art was equipped to bear such a burden. As it turned out, it was not thus qualified, but, in the meantime, the assumption that it was, added impetus to the idolatry of art.

Certain of the Dada artists, such as Max Ernst and Hans Arp, moved on to Surrealism, which preserved the playfulness of Dada but which found in man's unconscious the raw material of painting and sculpture. Foraging in the lower depths of the human mind, the Surrealists dredged up certain images, frequently erotic, that possess a recognizable character, always provided the viewer is prepared to take a similar plunge into his own sub-conscious. Yet much of the old Dadaist individuality lingers, and Surrealism never became the saviour of culture. I doubt that it even aspired to be.

The case was quite different, however, with another movement that blew into Western Europe from the east, on the winds of the Russian Revolution. Constructivism is the name it received, and, around 1921, the term denotes 'the determination of the artist and theorist to pursue the implications of a marriage between art and social revolution, even if this investigation meant a revision, or indeed a reversal, of existing conceptions'.[13] In their early, headier days the Constructivists purposefully pursued such a marriage. And how, we ask, did they go about achieving it?

The Constructivists welcomed the 'silly' activities of the Dadaists, if only because the latter cleared the ground upon which the former could then go to work. But their judgement of the Surrealists was considerably more severe, for these artists led art down a futile

and fanciful blind alley. '. . . we do not need', as Naum Gabo wrote, 'to undertake remote and distant navigations in the sub-conscious in order to reveal a world which lies in our immediate vicinity.'[14] Dreams cannot do duty for reality. The aim, instead, is to construct an art that is objective, scientific, and universal. These three terms – objective, scientific, and universal – summarize the constructivist programme and reappear again and again in the statements of these artists.

As all three words suggest, the individual subject must surrender any claim to autonomy. Neither in art nor in society does the last word belong to him. His much coddled 'intuition' will simply lead mankind astray in any number of different directions. As Michel Seuphor wrote in *Cercle et Carré*, the organ of the Constructivists in Paris, 'The subjective present everywhere, but everywhere reduced to a minimum of authority. Never again will it have the largest say in art. The subjective reigns only in epochs of amorous inaction, of incubation, childishness, and folly (revolution).'[15] So much for the Romantics, in all their various moods and guises. Science has overtaken them as well as their art. For, according to another spokesman, 'Art has evolved parallel to science, and today a purely constructive aesthetic has been created, one free from the figurative formalism of the past; an abstract plastic art, based on universal values, and on precise, mathematical laws.' 'And so, in spite of everything, though it is kept within these limits, the new plastic art continues all the same to propagate the new beauty among mankind, and assists in man's liberation by revealing to him the *unity*, the *universality* that is within him.'[16] These affirmations breathe an astounding (to us) optimism, all the more so in the case of the latter statement (written by the artist Jean Gorin), for it comes from a relatively late year, 1936, and the 'limits' of which it speaks refer to the tragic restriction of Constructivist art solely to the making of pictures and sculptures, while denying its expansive development within the total context of human culture. Constructivism thus viewed itself as offering a programme for the whole of society. And, moreover, it considered this programme of self-evident validity, grounded as it was upon scientific principles and an inherent universal order, which – note! – was comprehensible to all mankind. We shall not ransack modern history and uncover a clearer case of human optimism.

If we inquire, as I feel we must, just what art in fact issued from such a sanguine outlook, we can hardly do better than to appeal to *The Realistic Manifesto* of 1920, composed by the brother-sculptors, Naum Gabo and Antoine Pevsner. (Fig. 1.) 'The realization of our perceptions of the world', they write, 'in the forms of space and time is the only aim of our pictorial art and plastic art'. And they continue: '. . . we construct our work as the universe constructs its own, as the engineer constructs his bridges, as the mathematician his formula or the orbits'. There follows a whole series of renunciations, beginning with 'the yardstick of beauty', with its 'tenderness and sentiments'. Then:

> . . . in painting we renounce colour as a pictorial element, colour is the idealized optical surface of objects; an exterior and superficial impression of them;

colour is accidental and it has nothing in common with the innermost essence of a thing. . . .

We renounce in a line, its descriptive value; in real life there are no descriptive lines, description is an accidental trace of a man on things, it is not bound up with the essential life and constant structure of the body.

We renounce volume as a pictorial and plastic form of space; one cannot measure space in volumes as one cannot measure liquid in years; look at our space . . . what is it if not one continuous depth?

We renounce in sculpture the mass as sculptural element. . . .

Thus we bring back to sculpture the line as a direction and in it we affirm depth as the one form of space.

We renounce the thousand-year-old delusion in art that held the static rhythms as the only element of the plastic and pictorial arts.

We affirm in these arts a new element, the kinetic rhythms as the basic forms of our perception of real time.

Gabo and Pevsner address their Manifesto to people wherever they may be. It is their intention to remove art from the byways of life and to place it 'everywhere that life flows and acts . . . in order that the flame to live should not extinguish in mankind'.[17]

The Constructivists' struggle to invest their art with universal meaning necessarily led them to abstraction, to the suppression of the personal, of the representational, of colour, of linear descriptions, and of pictorial forms. They are not all absolutely faithful to this method (and, in general, one should beware of regarding the Constructivists as a completely homogeneous group). Among the most interesting of these artists was the Uruguayan painter, Joaquín Torres-García, who strove to achieve, within a Constructivist style, a harmony between classic (or universal) elements and romantic (or individual) ones. The composition of many of his paintings is based on the Golden Section, whose geometry the Greeks long ago found especially elegant and pleasing to the mind. But the figures within the compositions never quite lose representational character. They function, however, as symbols – these fish and suns, houses and arrows – symbols that express aspects of a universal order along with their manifold relationships to one another. (Fig. 2–3.) 'Faith', Torres wrote in 1932, 'in a total harmony outside of ourselves corresponds to our own harmony. For unity which is at the base of thought – and at the base of ourselves – should be at the base of the universe – and should equally be at the base of our works.'[18] An unabashed metaphysics underlies Torres's art.

Torres differed from his fellows in Constructivism by remaining aloof from the

political and social upheavals of his day, and therefore we can scarcely read into his art some blueprint for the organization of society. But if artists are poor guides to social reform, they are not much better as philosophers. If we take the trouble to delve into Torres's symbolism we find it at once arcane and banal. One commentator explains it in this fashion (and I have no reason to question her accuracy):

> For Torres-García, organizing the canvas is the conscious placement of abstracted imagery derived from nature within a grid; the final structure of the canvas depends equally upon balancing the architectural grid with the form of the symbols chosen to stand within it. In Universal Constructivism, this process of structuring is guided by the artist's reason and intellect [symbolized by a triangle], the macrocosmos of his being. Inspired by his emotions [symbolized by a heart], his intuitive manipulation of the paint and 'toning' of the colors are due to his unique inner spirit. This equally measured aspect of the form brings the magnetic spiritual quality, the mystery of the intangible, into his work and represents the mesocosmos of the soul. The intrinsic, earthy quality of the concrete materials that the artist chooses comes from the natural world, the microcosmos, which includes the animal, vegetable, and mineral categories [symbolized by a fish]. Thus each work has its own symbolic significance and is in itself an echo of Torres-García's idea of the cosmic plan.[19]

Were we simply to ignore his symbolism, Torres would have been greatly disappointed. And yet it is perfectly possible to read his paintings as strictly plastic works, as remarkably pleasing arrangements of lines, colours, and figures upon a plane of carefully chosen proportions. On this basis, they may still appeal to us as works of art, even if we know nothing about the principles of Universal Constructivism.

Similarly, the abstract work of the Constructivists lives on as art long after the death of their social pretensions. We may enjoy as art the sculpture of Gabo and Pevsner, the painting of El Lissitzky and Theo van Doesburg, quite apart from the ideological burden that their own creators sought to impose upon them. History has a tendency to foil and ultimately to bankrupt idolatries. So it was with the idolatry of the Constructivists. Their enchantment with the Bolshevik Revolution did not spare them the denunciation of Joseph Stalin, whose policies early in the 1920's demanded a form of Socialist realism quite at odds with at least the *artistic*, if not the human, ideals of the Constructivists. Then in 1922 there took place in Düsseldorf a Congress of International Progressive Artists. It was, in the words of one student, 'a clear sign of the widespread desire among artists to frame a common policy that would disregard national affiliations'.[20] Depending, I suppose, upon one's point of view, the annals of this Congress read either like low comedy or high tragedy. The upshot was chaotic. According to one report, the Congress eventually 'lost all sense of leadership and there was continual shouting going on'.[21] The Congress disbanded with each faction issuing its own statement or – yes! – manifesto. Here are two quotations from the statement that the Constructivists at the Congress published.

We define the progressive artist as one who fights and rejects the tyranny of the subjective in art, as one whose work is not based on lyrical arbitrariness, as one who accepts the new principles of artistic creation – the systematization of the means of expression to produce results that are universally comprehensible.

And then at the end of the statement, all in capital letters, this:

THE ARTISTS OF THE CONGRESS HAVE PROVED THAT IT IS THE TYRANNY OF THE

INDIVIDUAL THAT MAKES THE CREATION OF A PROGRESSIVE AND UNIFIED INTER-

NATIONAL IMPOSSIBLE WITH THE ELEMENTS OF THIS CONGRESS.[22]

This blunt recognition of the 'tyranny of the individual' did not cause the Constructivists forthwith to abandon their ambitious programme. It might have, but it did not. Their disillusionment proceeded more slowly, though eventually it overcame them, and their exalted hopes for the place of art in human society were extinguished. As an idol, art proved itself made of clay.

In the years between the two world wars, the Constructivists were not alone in their effort to forge a lasting bond between art and technological progress. A similar ideal informed the Bauhaus in Germany, the great school of arts and crafts, located first in Weimar and subsequently in Dessau. One of its chief figures, Lázsló Moholy-Nagy, hewed most consistently to this ideal, which, in turn, affected his understanding of man, who, he thought, 'must be treated in the same way as a machine: as a mechanism that must perfect all its functions, and that must be expanded by all creative means'.[23] It is typical of any idolatry that it 'flattens' the image of man, reducing his dimensions, while elevating only one or two to preeminence, as, in this instance, the mechanical one. Yet it should not be surprising that folk of this era were captivated by the idea of human 'engineering' and the attendant conviction that one might also engineer society. The promises of technology are endlessly beguiling, and artists are as susceptible as any other persons to their allure.

An individual artist of similar persuasion was the great French painter, Fernand Léger. Throughout his career, Léger maintained a deep personal identification with the common man, especially the labourer, his plight and his prospects. And it seemed clear to Léger that art might reduce this plight and brighten these prospects. He envisioned, as he wrote in 1924, 'A society without frenzy, calm, ordered, knowing how to live naturally within the Beautiful without exclamation or romanticism. That is where we are going, very simply. It is a religion like any other. I think it is useful and beautiful.'[24] Léger invested great confidence in the power of technology to achieve this goal and he designed his art both to reflect and to promote such a movement. (Fig. 4.) In a later chapter I wish to remark upon his aesthetic theories, but here at least some glimpse of his painting clearly illustrates his fascination with mechanics, with construction, and with the workers whose labours would realize the technological ordering of society. At times his vision seems

almost rapturous in its intensity and simplicity. 'Every objective human creation', he wrote, 'is dependent on absolute geometric laws. Every human creation is in the same relationship'.[25] Looking back, we find oddly prophetic some of Léger's suggestions for life in an urban technocracy. In jest, we assume, he advocated the demolition of New York (and nominated Marshal Pétain for the job!), to be replaced by a city of glass buildings. The modern glass skyscrapers of Manhattan come rather close to fulfilling Léger's prescription. Moreover, he proposed the employment of 300,000 unemployed workers to sandblast the buildings of Paris, so that the city would emerge all white. The scrubbing of Paris, initiated by André Malraux, has now revealed to us Léger's Paris *toute blanche*.[26] But the workers failed to share the painter's dream. The comprehensibility of his art, upon which Léger so steadily relied, proved to be an illusion. The common man just did not get the point, and, like the Constructivists, Léger suffered disappointment over the impact of his thought and his work.

All these artists – Léger and Gabo, Lissitzky and Torres-García – were convinced that art could generate a universal visual syntax. It could communicate with all because it would be based upon principles general to all, scientific in their rigour and validity. Thus armed, art would lead all men into the promised land of the twentieth century; art would reverse the consequences of the Tower of Babel. Poor art. Poor artists. The dreams died in the bread lines of the depression and the blitzes of the Second World War. Art, after all, was not destined for the role of cultural saviour, and this particular form of its idolatry passed, with few laments, into history. And yet after the war, the idolatry re-emerged, transformed, and it entered what I can only call (for reasons that I shall try to explain) a 'gnostic' stage. For that portion of the tale we must cross the Atlantic to the United States.

NOTES TO CHAPTER 2

1. Quoted in Wassily Kandinsky, *On the Spiritual in Art* (New York: Solomon R. Guggenheim Foundation, 1946), 127ff.
2. Quoted in Jacques Barzun, *The Use and Abuse of Art* (Princeton: Princeton University Press, 1974), 27.
3. Quoted in William McCleery, 'A Business Man & Art Collector Talks of Art (& Business)', *University: A Princeton Quarterly*, No. 60 (Spring, 1974), 28.
4. Harold Rosenberg, *The Anxious Object: Art Today and Its Audience* (New York: The New American Library, 1966), 166.
5. *Ibid.*, 196.
6. Hilton Kramer, review of *The Use and Abuse of Art*, *The New York Times Book Review*, June 23, 1974, 2.
7. Barzun, 90.
8. *Ibid.*
9. Quoted in Hilton Kramer, 'Underground Soviet Art: A Politicized Pop Style', *The New York Times*, September 29, 1974, Section D, 27.

10. Philip Rieff, *The Triumph of the Therapeutic: Uses of Faith After Freud* (New York: Harper & Row, 1966), 257f.
11. Edmund Wilson, *Axel's Castle* (New York: Charles Scribner's Sons, 1959), 106.
12. *The Dada Painters and Poets: An Anthology*, Robert Motherwell (ed.) (New York: George Wittenborn, Inc., 1967), 77.
13. Stephen Bann, *The Tradition of Constructivism*, Stephen Bann (ed.) (New York: The Viking Press, 1974), 4.
14. Quoted in *ibid.*, 213.
15. Quoted in *ibid.*, 184f.
16. Jean Gorin, 'The Aim of Constructive Plastic Art,' quoted in *ibid.*, 200.
17. Quoted in *ibid.*, 9f.
18. Barbara Duncan, *Joaquín Torres-García, 1874–1949: Chronology and Catalogue of the Family Collection* (Austin: The University of Texas at Austin, 1974), 86.
19. *Ibid.*, 87.
20. Bann, 58.
21. *Ibid.*, 62.
22. *Ibid.*, 68f.
23. Geraldine Weiss and John David Farmer, *Concepts of the Bauhaus: The Busch-Reisinger-Museum Collection* (Cambridge: The President and Fellows of Harvard College, 1971), 15.
24. Fernand Léger, *Functions of Painting* (New York: The Viking Press, 1973), 47.
25. *Ibid.*, 24.
26. Edward F. Fry, Introduction to *ibid.*, x.

Chapter 3

Art's Absorption of Culture

IN THE UNITED STATES between the two wars numerous artists shared the
social optimism of Léger. Theirs, like his, was based upon the confidence that they
reposed in technological progress and in the triumphs of the machine. On the political
front, the New Deal, proclaimed by President Roosevelt, contributed to this optimism.
In typically American fashion, the temper of these artists is pragmatic and activist. As a
representative of their number we may take the painter, Stuart Davis, who recommends
himself in part for the reason that he was a very articulate writer.

He sounds a note often echoed by other artists of our century when he affirms that art's
typical public in the past was 'primarily composed of a very small class of society with
large incomes', a situation which 'left much to be desired. This economically enfranchised
class automatically dictated, through their patronage, the art taste of their time. No artist
could be free from their vulgar domination'.[1] Moreover, every artist had to funnel his
art through the hands of private dealers, who, perforce, catered for the tastes of the rich.
But now, thinks Davis, the times are changing (he is writing in the 1930's, during the
depression). Artists can open and administer their own galleries, and thereby 'a cultural
impetus will be established in the community which will make possible a powerful art
expression, having its roots in the masses of the American people'.[2] The government's
support of artists (who were in fact employed by such agencies as the Works Progress
Administration during the early days of the New Deal) contributes toward this same
end.

To Davis, artists are, in a word, workers, similar to labourers in industry. It is therefore
perfectly natural that they should organize unions and hold congresses. At one such con-
gress, held in New York City in 1936, Davis served as secretary and he addressed the
gathering. The depression, he told his listeners, had 'inevitably reached the world of art,
shaking those psychological and aesthetic certainties which had once given force and
direction to the work of artists', who, in the face of the social and economic crisis, could
no longer 'remain aloof, wrapt up in studio problems'.[3] They must form unions, engage
in militant demonstrations, and demand from the government the support to which
artists, like other workers, are entitled. That demand, as Davis sees it, possesses a

thoroughly democratic flavour, not being restricted in its scope to a select few but rather encompassing the mass of artists. He hails the 'democratic extension of government support to young and unknown artists', which 'has brought out a vast variety of talent completely ignored by private patronage and commercial galleries'. 'Even if we were to rally all the American artists to our cause', he told the congress, 'we would achieve little working as an isolated group. But we have faith in our potential effectiveness precisely because our direction naturally parallels that of the great body of productive workers in American industrial, agricultural and professional life.'[4]

It is most interesting to observe Davis's ideas concerning the social importance of art. Being himself a painter of abstract subjects, he defends the social content of that style. (Fig. 5.) He draws a comparison between Daumier and Seurat and asserts that it would be vain to argue that the pictures of the former possessed social content while those of the latter did not, on the grounds that Daumier 'painted the daily life of the workers' and Seurat 'the leisure enjoyments of the bourgeoisie. The matter', Davis adds, 'is not so simple'. True, Daumier's subjects 'were active and progressive in meaning. But Seurat's conception of the form and spatial relations through which his subject exists was revolutionary. The objective and social formal concept of which Seurat's pictures are the record, is a vital part of the cultural inheritance of all the people. To argue that it is not is to argue that the people are unworthy of the fruits of their own greatest talents.'[5] I am not at all sure that Seurat viewed his own achievement in any such light, but that is how Davis saw it and he was sure, in any case, of art's indispensable role in social progress. 'Some very stubborn artists', he acknowledged,

> may like to believe that art is not the proper tool for fixing things that are out
> of order on the political or economic level, and they may oppose its use for such
> purposes, fearing art itself will be destroyed in the bungling attempt. They may
> 'idealistically' conceive art to be an independent and special form of social
> action, in which the solutions made do not exactly coincide in time with
> solutions in other fields. Genuine art may be produced in a very chaotic society,
> and it may be the most important organizing force for progress at such a period.
> It may be the only concrete symbol of the possibility of order when every joint
> in the social plumbing is aleak.[6]

The affinities between Davis, on the one hand, and the Constructivists and Léger, on the other hand, are, I suppose, perfectly clear. Perhaps Davis is brasher in his optimism and he certainly exhibits the American passion for practical organization. He is less theoretical in his statement, speaking of the solidarity of the artists and the masses, rather than the universal forms of an art based upon mathematics and science. But the net result is not so different. Art stands at the forefront of social progress, leading the way into the future. Even in the most chaotic times its beacon is not extinguished, and that light beckons men to an enduring democratic order in which justice and peace shall prevail. The disillusionment that Davis suffered is not so different, either, from that suffered by Léger

and the Constructivists. In the 1930's he held it to be the duty of artists to stand with all workers against fascism and the threat of war. But that stand failed. War did overtake the West, and fascism ran its destructive course. On November 25, 1947, Davis took part in a symposium at the Museum of Modern Art in New York, a symposium devoted to Picasso's celebrated painting, *Guernica*. If any work of art should provoke social comment, this is the one. Yet on that occasion Davis remarked:

> Why should the painter be looked to for answers to Political and Moral problems that the strongest forces in the world today cannot answer? This point is raised because questions of this kind have centered around Picasso's *Guernica* since its inception. It has been repudiated as arrogant egotism on one hand, and lamented over as failing to fulfill its promise on the other. It is Degenerate Bourgeoise Art to some, and a sad proof of the failure of an Epic Hero to emerge to others. I look at it in a different way. In fact, I just look at it in a way I look at any other painting and do not inquire into its origins nor the intellectual and prophetic scope of the artist.[7]

The New York artist of the 1930's came finally to the painful realization that 'art could not reach beyond the gesture on the canvas without entering into a complex of relationships alien to his deepest feelings'. He 'had dedicated his work to movements designed to change those relationships; he had ended by finding that the ideologies of both revolution and reform led to consequences that were humanly questionable, emotionally frustrating and a drag upon creation'.[8] The artist's solution was to back out of this dead end and to take refuge in, precisely, his own art. Davis's statement of 1947 clearly reflects this shift.

There appeared on the New York scene in the 1950's a group of artists whose paintings exemplify this concentration upon the work of art itself. They have been dubbed, for good reason, 'Action Painters', and the most famous of them are probably Willem de Kooning and Jackson Pollock. (Fig. 6–7.) Neither their ideas nor their works betray any suggestion that art proposes solutions to those political and moral problems of which Davis spoke. Instead, to them the canvas is an arena, virtually a battlefield, upon which they vent their own emotions. Hence they are sometimes termed 'Abstract Expressionists'. For the most part their canvases are oversized, enlarged fields across which they pursue their struggles. The 'combat' (if I may call it that) is not only manual but bodily in character. One recalls the stories of how Pollock discarded his brushes, laid out his canvases upon the floor, and proceeded to stand on them while he dribbled or smeared paint across their surfaces. To many, the entire procedure is at best amusing, at worst outrageous, though these works ought not be dismissed in either manner. Their implications are manifold.

In the first place, they are exceedingly personal statements, almost emotional autobiographies. The artist makes no pretence of offering us a picture that embodies universal meaning; he addresses no 'message' to society. He gives us instead an account of his fight to express with paint, on canvas, his own private passions. He is an exhibitionist, if you

wish, and he makes no apology for the fact. Nor, in the second place, does he try to conceal the concrete development of the struggle. Quite the contrary, he enables us to follow virtually every movement, every gesture, that led to the final form of the work. And we, the viewers, if we respond, share with the artist, step-by-step, the travail through which the painting was created. Through our own imaginative projection into the work and its rhythms we 'know' the solitary person, the artist, who was physically there before us. The life of the painter and the life of the viewer encounter one another in the turbulent movement of the painting.

Now, if this is a fair assessment of the Action Painters and their art (and I believe it is), we find ourselves in a new and rather unfamiliar situation. Much earlier in our century, P. T. Forsyth remarked, 'It is only the very lowest forms of Art, like the acrobat's that depend on self-exhibition. The true artist has this much from the Holy Spirit – "He shall not speak of himself". Art is not there for the artist. It is not there to reveal his temperament. It is to let us see Nature through a temperament – which is a very different thing. It is not good for Art when the public makes more of the actor than the part, and of the artist than of his work'.[9] Today, it is hard to read that comment without irony, though if Forsyth were still alive he might very well stand by it. It is certainly true that in his own day it had much to justify it. As a contrast to Action Painting, one might consider a picture by Jan van Eyck, such as the famous Arnolfini marriage portrait in the National Gallery in London. Not only does the substance of the painting tell us nothing of the artist, but he has also gone to great lengths to conceal the very brush strokes by which the picture was composed. We cannot even trace the movement of the artist's hand in the physical creation of the work. If we know anything about van Eyck it is that, in his art, he insisted upon remaining utterly anonymous. And so he does remain, examine whichever of his paintings you choose. The art masks the man. But a Pollock or a de Kooning thrusts himself and his own existence into his art. Nor, to revert to Forsyth, does he interpret nature for us. It is instead the 'landscape' of his own inner life that he projects through the picture. He comes across as a sort of hero, struggling with recalcitrant and alien forces within him, over which he prevails in the act of making his painting. It is quite futile to try to separate the artist from his work, because his life constitutes its very substance. We stand here at the end of another very long line of development that begins at least as early as the self-portraits of Rembrandt. But an artist certainly need not be restricted to self-portraiture if he wishes to inject his own person into his work. One may look, for example, at a landscape or a still life by Chaim Soutine and see perfectly readily the distraught state of the artist's own mind. (Fig. 8.) From this point, the step to abstraction is no great leap, particularly in view of the established tradition of non-representational art.

But one difference does suggest iself, and an important one for our purposes. Art that represents concrete objects, however vaguely, tends to guide and control the imagination of the viewer by constantly recalling it to the very objects depicted on the canvas. They

are 'bases' from which to some extent we may wander, but ever and again we must return to them. Action Painting imposes no such direction upon us. Quite the contrary, it allows *us* to impose meaning upon *it*, and therein lies its great suitability as an idol. Moreover, as the painter is so intimately bound to the work, we inevitably draw him as well into the circle of idolatry. I cannot say that these artists meant us to regard them as the titanic heroes, the demi-gods of our day. Whether or not they aspired to such an eminence, we have bestowed it upon them. To our culture they represent par excellence the victors who have wrestled with and conquered the inner disorders that afflict us so variously and so relentlessly; and their paintings are both records of the battle and tokens of the victory, unassailable demonstrations that from his private chaos man can yet wring order. These artists are the 'pioneers and perfecters' of a new faith, who lure the rest of us, cast in a more fragile mould, to follow them and to share, if we are bold enough, in their own conquest.

I can myself think of no art so different in use and intent from the art of the Constructivists. By its very nature Action Painting is subjective, not objective; it is personal, not universal; it is spontaneous, not methodical. Yet it too issues in a kind of idolatry. It promises man release, release not from the unjust shackles of society but release from that inward bondage by which man holds *himself* in thrall. If art affords such a precious liberation as this, is it not worthy of human devotion? Or is it in reality an *ignis fatuus*, a heap of ashes that can never answer the ardour of the restless heart Augustine described so long ago?

If Action Painting was saturated with the life of the artist and drew into its own composition the existence of its viewer no less than that of its creator, there followed, as a next step, a logical and inevitable reversal of this process: the work of art moved outward into the lives of people, into human culture. In order to illustrate this development we must turn to the works of a still more recent group of artists in the United States whose aim has been not the renunciation of the culture with which they are familiar, but rather its incorporation, incorporation into their art of such 'vulgar' and popular products of culture as comic strips, advertisements, and road signs.[10] The label 'Pop Art' has been attached to their work, and it will do as well as any other.

The figure who probably best represents this outward movement of art into culture is Robert Rauschenberg. (Fig. 9.) He has said of himself that he sees no reason why the world should not be regarded as 'one gigantic painting' and therefore he proceeds to incorporate the world into his art 'by means of an appetitive and enthusiastic embrace'.[11] The result is often an apparently heterogeneous collection of artifacts, some represented in paint, some physically present in the work, but all of them sucked up from everyday culture and deployed by the artist in his own fashion. This procedure obviously violates formal aesthetic canons, which have always dictated that a picture must display an internally coherent form. A random cluster of shapes and objects simply is not a work of art. Rauschenberg and the other Pop artists dispute this conclusion. They argue that a work of

art may be a 'partial sample of the world's continuous relationships . . . a rendezvous of
objects and images from disparate sources, rather than . . . an inevitably aligned setup . . . a
conglomerate, no one part of which need be causally related to other parts; the cluster is
enough'.[12]

Before we examine this viewpoint and the art that flows from it, let me make one
additional observation concerning Pop Art. It is frequently regarded as an art of signs and
sign systems. This feature is evident enough in its use of common objects, but it is even
more obvious in the Pop artists' employment of words as objects. Time after time they
introduce advertising slogans or the statements we encounter in comic strips, and very
often an individual word may itself serve the artist as an object to paint. One interesting
example of the last is a painting by Jasper Johns of the word, 'Tennyson', suggesting as it
does the readiness of the visual artist to appropriate poetic art for his own purposes. This
mingling of the visual and the verbal also violates the traditional principles of aesthetics.
But the point about these signs, whether objects or words, is the elusiveness of their
meaning. On the surface, of course, their meaning is perfectly literal, and we have no
trouble reading it, since they constitute the most prevalent and familiar artifacts of our
culture. Quite simply, they are clichés. But having removed them to a new context, the
artist confronts us afresh with the problem of their meaning, and the solution to that
problem is a very difficult one indeed, for the works breathe an almost grim ambiguity.
Jasper Johns mentions that he chooses for his subject matter 'things the mind already
knows'. But before he has finished with them the mind is not at all sure what it *does* know!
In one series of works, Johns painted an ordinary marksman's target and along the top of
the picture he arranged a row of small wooden boxes that contained, in plaster, fragments
of the human anatomy – a head cut off at the top, an ear, some toes, genitalia, and so
forth. To each box the artist attached a hinged flap that might be dropped, thereby con-
cealing the object located within. (Fig. 10.) Readers of signs could have a field day with
these targets and boxes, making of them almost anything they choose. Johns, however,
does not offer them any help. One assumes that each sign has its own particular meaning
for him, but he is not interested in telling what it is, to say nothing of imposing that
meaning upon the viewer. We are back to the anonymous artist.

And yet these artists, however anonymous they may be, are indeed, in their works,
telling us something. And I should think that they are telling us exactly the opposite of
what the Constructivists were saying. They have implicitly rejected any universal and
fundamental ground of human unity. Such unity as does exist is based upon the ordinary
objects of our culture, which are shared by all alike. (Fig. 9.) But the interpretation of
these objects immediately reveals the disparity that lies just beneath the surface. As signs,
these artifacts may and do bear a multitude of meanings, almost as many as there are
persons to read them. We all perceive the same objects; we all grasp them differently. I
do not believe it an exaggeration to say that Rauschenberg's theory concerning the work
of art reflects just this diversity. In a culture so heterogeneous as our own, the artist who

appropriates its artifacts would produce a counterfeit if his work displayed tightly integrated formal elements. Or would it be a work of sheer genius? Whichever is the case, the Pop artists are not so much concerned with the artistic transformation of culture as they are with its artistic elucidation. For all their vigour and enthusiasm, I do not suggest that they like what they find and for this reason I spoke of the 'grim ambiguity' of their art. In Pop Art one finds no humour, only irony.

I said also that they represent a movement whereby art has reached outward to the appropriation of culture. I judge this development to be so important for our theme of the idolatry of art that I wish to dwell upon other aspects of it. As I do so, I shall remain with the artistic scene in the United States but I do not therefore imply that it is unique. On the contrary, there would be no difficulty locating parallel developments in Europe and Great Britain.

Coincident with the advent of Pop Art there burst upon the artistic world a strange phenomenon called 'Happenings'. As the name suggests, they were as much events as objects. For that reason as well as others they defy illustration. The artist Allan Kaprow however, a leading producer of these events, describes a Happening with these words:

Everybody is crowded into a downtown loft, milling about like at an opening. It's hot. There are lots of big cartons sitting all over the place. One by one they start to move, sliding and careening drunkenly in every direction, lunging into people and one another, accompanied by loud breathing sounds over four loudspeakers. Now it's winter and cold and it's dark, and all around little blue lights go on and off at their own speed, while three large brown gunny-sack constructions drag an enormous pile of ice and stones over bumps, losing most of it, and blankets keep falling over everything from the ceiling. A hundred iron barrels and gallon wine jugs hanging on ropes swing back and forth, crashing like church bells, spewing glass all over. Suddenly, mushy shapes pop up from the floor and painters slash at curtains dripping with action. A wall of trees tied with colored rags advances on the crowd, scattering everybody, forcing them to leave. There are muslin telephone booths for all with a record player or microphone that tunes you in to everybody else. Coughing, you breathe in noxious fumes, or the smell of hospitals and lemon juice. A nude girl runs after the racing pool of a searchlight, throwing spinach greens into it. Slides and movies, projected over walls and people, depict hamburgers: big ones, huge ones, red ones, skinny ones, flat ones, etc. You come in as a spectator and maybe you discover you're caught in it after all, as you push things around like so much furniture. . . . Long silences, when nothing happens, and you're sore because you paid $1.50 contribution, when bang! there you are facing yourself in a mirror jammed at you. Listen. A cough from the alley. You giggle because you're afraid, suffer claustrophobia, talk to some one nonchalantly, but all the time you're *there*, getting into the act.[13]

Well, perhaps that description sounds like nothing so much as a Grand Guignol, and, to be sure, Happenings possess a theatrical element that is an indelible part of their makeup. As Kaprow points out, however, they differ from conventional theatre in a variety of ways. They do not occur in playhouses but in lofts or basements or vacant stores. They have no plot. They are dominated by chance. And, finally, they are impermanent; they cannot be repeated. My own concern, however, is to place them within the context of artistic developments, especially the voracious drive of art to embrace culture in its entirety.

Kaprow observes that Happenings emerge 'out of the rites of American Action Painting'.[14] As we have observed, the painting of a picture by a Jackson Pollock was itself an event with its own struggle, drama, and risks. The picture then became an object that invited the spectator to participate in the event of its own creation, to take an imaginative share in the artist's own act. A Happening goes one step further and transforms the spectator into a participant. In Kaprow's words, 'You come in as a spectator and maybe you discover that you're caught in it after all . . . you're *there*, getting into the act'. No amount of psychological involvement with the work of an Action Painter could overcome sheer physical detachment. With a Happening, that last barrier falls, and art now draws into its domain the entire person, body as well as mind. There is nothing accidental about this outcome, this relentless appropriation by art of its total environment. To cite Kaprow again: 'I think that, today, this organic connection between art and its environment is so meaningful and necessary that removing one from another results in abortion'.[15] It may be that *confusing* one with the other also results in abortion. We shall see. For the moment, I propose to examine one final turn that American art has taken in recent years.

We have been treated to a series of weird antics by persons who proclaim themselves artists and then proceed to engage in very strange 'works'. One of them built an igloo at the entrance of the Whitney Museum in New York. Another dug away a part of the museum's foundation, ground it to dust, and presented the dust as a work of art. Still another, in Los Angeles, managed to have himself shot and, alternately, crucified; he also has crawled on his bare stomach across fifty feet of broken glass. The explanation, if there is one, for such odd behaviour, lies partly in that recurrent tendency of artists to break away from dependence upon dealers, museums, and collectors. There was nothing to sell and nothing to buy. But these acquirers of art are a very inventive lot and they managed to re-establish the old prevailing dependence. Picture books of that Los Angeles artist's activities, for example, now sell for hundreds of dollars!

But the results in the marketplace need not detain us. Of far greater importance is the account these artists give of their own doings. They maintain that the significance of their art lies not in their actions or the objects they produce but rather in the thought that lies behind both. The idea itself has now become a work of art, and therefore these artists have been labelled 'Conceptualists'. Among their number is a man named Sol Le Witt, whose practice it is to furnish detailed instructions for the making of a work, with the

result that one can produce it wherever one likes. 'Since', as one commentator points out, 'it's the idea that counts it doesn't matter at all whether it's you, Sol Le Witt or your Uncle Elmer who does the making.'[16] One artist, a certain Ian Wilson, simply talks. You might commission him to do a 'work' for you, and he would drop by for a conversation, in which the two of you would discuss, say, Plato (a peculiarly appropriate subject for a Conceptualist). At the end of the conversation the artist would give you a receipt, reading: 'On the 23rd of January, 1975, there was a discussion between John Smith and Ian Wilson. What was said remains in the collection of John Smith.'[17] To quote one dealer in conceptual art, '. . . the art becomes so abstracted there is no object whatever. Yet in a way there is always an object because an idea can be a subject. There is, also, always the piece of paper, the bill of sale, which says you bought it.'[18]

All quite ludicrous. Yes, of course it is. But it is also very telling, because it represents art's ultimate imperialism, its effort to capture the realm of ideas and to employ ideas themselves as artistic expressions. The devotees see nothing contradictory in this effort. As one says, 'Now the human mind itself is a sculptural thing. If people cannot see ideas as sculpture, they are not extending their minds enough'.[19] Yet the game is dangerous, dangerous for art. Historically, idea has tended to devour object, not vice versa, and art may suffer the same fate as the Young Lady from Niger. One critic makes the point with these words: 'Of all *liaisons dangereuses* none is considered more perilous to the artist than living with ideas. In that alliance, every passion is diluted by argument, every response of sensibility by examinations of purpose. The quiet exercise of talent is out of the question, and one may wake up any morning to discover that the conceptual bitch has run off with everything.'[20]

I cited in the last chapter the 'gnostic' stage in the idolatry of art, which we have entered since the Second World War. I have tried to illustrate what I mean, by tracing various trends in American art during that period. Art has engaged in a relentless spread across the landscape of our culture. Its powers of absorption seem almost limitless, and they remind me, at any rate, of the proliferation of gnosticism in the second century. In principle the artistic vacuum cleaner may sweep up anything; nothing is exempt, no object, no event, no idea. If art may be anything, then anything may be art.

The price, to be sure, is a heavy one. Like gnosticism, art tends to lose its concrete identity; it lacks shape, discreteness, legibility. This threat has not gone unobserved. Here is another statement by Allen Kaprow, that impresario of Happenings: '. . . our advanced art approaches a fragile but marvelous life, one that maintains itself by a mere thread, melting into an elusive, changeable configuration, the surroundings, the artist, his work, and everyone who comes to it'.[21] This result condemns art, like gnosticism, to irrationality. One cannot get a grip upon the very meaning of the term. Yet in a society where art (whatever it actually is) plays so crucial a role, people quite predictably want to understand it and to enjoy for themselves its benefits. Consequently, our culture has bred an élite, a cadre of gnostic priests, the elect, who dispense to the masses the arcane wisdom embodied

in art. Most of the wisdom is foolishness, of course, in perfect fidelity to its subject matter, but it is spoken and heard in an awesome aura of authority. As usual, people get what they ask for. In my judgement, it would be far healthier, far more honest, to say of art, 'If a person enjoys it, if it amuses him, if, in whatever its form, it sweetens his time, then let him pursue his pleasure.' But the matter can hardly rest there, since man's mind is not only a perpetual factory of idols; it is as well a perpetual factory for explanations of idols. The flow of words that accompanies art in our day comprises a veritable inundation, made up of theories, rationales, and justifications, debates, controversies, and arguments. It is not in man's nature to erect an idol – and then leave it alone. He is bedeviled by his own creation, which like a scolding mistress will not settle for less than his complete attention and affection. No, he will not abandon it until its charms fail and it no longer offers him the satisfactions he craves. I do not myself discern in our own day a waning of art's allure, which lies, perhaps as I suggested earlier, in its very diversity. Somewhere in this amorphous mass called 'art' any diligent seeker will find reward. It may also be the case that our culture possesses an unusual capacity to tolerate the absurd.

I can myself think of no single course of action that the Church has uniformly adopted in the face of idolatry. Outright attacks upon it are usually futile, since the devotees are too preoccupied with the idol to notice the attack. Ridicule is perhaps more effective. Best of all, it seems to me, is that blend of wisdom and innocence that Jesus commended to his disciples. The wisdom in this case must be the discernment of those signs of our times about which I have been speaking, while the innocence requires us not to permit this idol or any other to seduce us from the Lord's service. At the same time we cannot wash our hands of art. It is one thing to lament its idolatry; it is another rightly to appraise God's gifts of painting and sculpture, of which Calvin spoke. It is to that latter task that I should like to address myself in the remaining chapters.

NOTES TO CHAPTER 3

1. *Stuart Davis*, Diane Kelder (ed.) (New York: Praeger Publishers, 1971), 151.
2. *Ibid.*,
3. *Ibid.*, 158f.
4. *Ibid.*, 162.
5. *Ibid.*, 16.
6. *Ibid.*, 165.
7. *Ibid.*, 176.
8. Rosenberg, 18.
9. P. T. Forsyth, *Christ on Parnassus* (London: Independent Press Ltd., 1959), 256.
10. Lawrence Alloway, *American Pop Art* (New York: Collier Books, 1974), 7.

11. *Ibid.*, 55.

12. *Ibid.*, 5.

13. Allan Kaprow, ' "Happenings" in the New York Scene', *Art News*, Vol. 60, No. 3 (May, 1961), 57f.

14. *Ibid.*, 58.

15. Even this statement does not fully suggest the 'voraciousness' of Kaprow's art. Critic Lawrence Alloway writes: 'Loft and gallery are too geometric for Kaprow now; open country, a secondary theme in some early writing, is now the scene. Redrawing the lines of demarcation between different art media is no longer enough; not only have these media lost their "traditional identities", but Kaprow proposes "moving and changing locales" and "variables and discontinuous" time as well. To the continuity of the one art with another, he has added fluidity of architecture with art and nature in one big loop'. Lawrence Alloway, *Topics in American Art since 1945* (New York: W. W. Norton & Co., 1975), 196.

16. Roy Bongartz, 'Question: How Do You Buy a Work of Art Like This?,' *The New York Times*, August 11, 1974, Section 2, 19.

17. *Ibid.*

18. *Ibid.*

19. *Ibid.*

20. Rosenberg, 122.

21. Kaprow, 59.

Part II

ART, CREATION and RECREATION

Chapter 4

Beauty and Power in Art

JOHN CALVIN has imparted to his theological descendants a certain legacy that is both a burden and a glory. In brief, it is the obligation of faith to strive for understanding, and, while Calvin did not originate the idea nor even put the matter quite that way, it is forever imbedded in his conviction that faith is a kind of knowledge, that it possesses an indelible noetic content, and that our task is to unfold that content. We may not settle for the blind faith that Luther so poignantly describes in his Lectures on Galatians.

> . . . if it is true faith, it is a sure trust and firm acceptance in the heart. It takes hold of Christ in such a way that Christ is the object of faith, or rather not the object but, so to speak the One who is present in the faith itself. Thus faith is a sort of knowledge or darkness that nothing can see. Yet the Christ of whom faith takes hold is sitting in this darkness as God sat in the midst of darkness on Sinai and in the temple. . . . Therefore faith justifies because it takes hold of and possesses this treasure, the present Christ. But how He is present – this is beyond our thought; for there is darkness, as I have said. Where the confidence of the heart is present, therefore, there Christ is present, in that very cloud and faith.[1]

If, to Calvin also, faith has a blind element, it is due to human sin and ignorance on the one hand and to the inexhaustible riches of God on the other hand. Neither, however, offers the believer any excuse to suspend his understanding, and his obligation to exercise it stems ultimately from God's gracious accommodating of himself to human comprehension. I therefore regard the remaining three chapters as an effort of faith to gain understanding. They are my effort to comprehend the specific belief that I share with Calvin, that painting and sculpture *are* gifts of God. Therefore we should try to grasp them as such. So far as I can tell, Calvin never applied himself to this particular task. I do not mean to suggest that I am going to make up what is lacking in the *Institutes* or in any other part of Calvin's theological corpus! I merely want to engage in a modest attempt of faith to seek understanding. How modest it is will presently appear! And I offer it as a tentative statement.

Re Rothko

In a famous passage from the *Summa Theologica* Thomas Aquinas observes that 'beauty includes three conditions, *integrity* or *perfection*, since those things which are impaired are by the very fact ugly; due *proportion* or *harmony*; and lastly, *brightness*, or *clarity*, whence things are called beautiful which have a bright color'.[2] Thomas makes this remark in the course of his discussion of the divine names. 'Beauty' is a proper name for God. And then Thomas proceeds to appropriate this perfection specifically to the Son, since beauty, he argues, bears a special 'likeness to the property of the Son'. As concerns integrity or perfection, the Son possesses *in full measure* the being of the Father. Nothing is lacking; no ugliness impairs this utter perfection. As for proportion or harmony, Thomas declares, following the Epistle to the Hebrews, that the Son is the 'exact image' of the Father. Without distortion in any respect, he completely mirrors the being of the Father and thereby maintains the precise harmony of that being. We should pause to note that what Thomas here says of the second person of the Trinity is true equally of Jesus Christ, the Word incarnate. It is, after all, about him that the author of Hebrews is writing. Moreover, we have in the first book of *De Principiis* Origen's remarkable metaphor of the statue, itself a direct exposition of Hebrews 1 : 3. Let us imagine, says Origen, a statue of such vast size that it fills the entire world and is therefore beyond the ken of human perception. Then suppose, he continues,

> that another statue was made similar to it in every detail, in shape of limbs and outline of features, in form and material, but not in its immense size, so that those who were unable to perceive and behold the immense one could yet be confident that they had seen it when they saw the small one, because this preserved every line of limbs and features and the very form and material with an absolutely indistinguishable likeness.[3]

Christ therefore preserves, though on a different 'scale', the very harmony and proportion of the divine, thus exhibiting one condition of God's own beauty.

And what of the third condition of beauty, in many ways the most interesting – that of brightness or clarity? It is not accidental, I am sure, that Origen employs his metaphor for the purpose of indicating how it is that we, 'who were not able to look at the glory of pure light while it remained in the greatness of his godhead, may find a way of beholding the divine light through looking at the brightness', which is, of course, Jesus Christ. The association of God with light and of Jesus Christ with light is so prevalent in Scripture and so hallowed in the thought and piety of the Church that no single chapter nor book, like this one, could possibly exhaust the theme. It appears in the allusions of the Old Testament to the 'shining splendour' of the Lord. In the New Testament one classic instance is Paul's declaration that 'it is the God who said, "Let light shine out of darkness", who has shone in our hearts to give the light of the knowledge of the glory of God in the face of Jesus Christ'. (2 Cor. 4 : 6). Light, of course, is a central image of the Fourth Gospel. Throughout the history of the Church it crops up time after time in all those discussions of the Holy Spirit's illumination of the hearts of men and it is enshrined in worship in

such hymns as 'O Splendour of God's Glory Bright, From Light Eternal Bringing Light'. The ramifications are endless, and I cannot possibly do them justice. Consequently, I must content myself with only a few remarks.

First, the image of light suggests clarity, especially intellectual clarity. For Origen, of course, that was the important point. Jesus Christ swept away the darkness that pervaded the human mind and illumined it with true knowledge. He replaced ignorance with the divine wisdom; he 'enlightened' mankind. Speaking for myself, I should be the last to disparage *this* interpretation of light and of its importance in understanding the work of Jesus Christ. After all, *this* Calvinist still thinks of faith as knowledge and cannot very well relinquish the conviction that Jesus Christ is not only the way and the life, but also the truth! Carrying water on both shoulders, I also side with Thomas Aquinas, who is entitled to his own say on this subject, since it is with him that we began. And Thomas says just this: 'The third [condition of beauty – that is, brightness or clarity] agrees with the property of the Son, as the Word, which is the light and splendor of the intellect. . . .' In trinitarian theology, the second Person, the Word, has always stood for order, rationality, coherence – the 'brightness' of the divine mind. It is somewhat rarer to appropriate beauty to him as well, and when a theologian like St. Thomas has done so he usually means beauty of just this intellectual, immaterial sort.

Now there is no question that the mind of man does desire such intellectual clarity, which is achieved so exactly within the realm of mathematics. I recall a remark of Isak Dinesen, who flying over her Kenya coffee plantation and noting from the air its neatly laid out form amidst the wildness of the countryside, said that she realized at that moment 'how keenly the human mind yearns for geometrical figures'.[4] Or, to put the point in the words of a philosopher, 'Pythagoreanism is inborn in the human mind'.[5] Perhaps it is for this reason, among others, that Thomas so promptly removes his discussion of beauty to a spiritual plane and there leaves it. The Thomistic 'active intellect' is forever at work in that fashion, methodically peeling away the sensuous determinants of an object in order to grasp its latent, invisible form – and thereby accomplishing what one teacher of mine used to call an intellectual striptease!

But need we subject a beautiful object to this sort of treatment? Have we any warrant for such an act, this discarding of the sensuous husk while preserving that which is intelligible to the mind alone, this sacrifice of the body's eye to that of the mind? The answer, in my judgement, is no, and almost all else that I intend to say in this and the following chapters might be construed as an 'apology' for that answer. But our subject is art, and artists of course have recognized the intellect's desire for clarity of a geometrical rigour, In an earlier chapter I mentioned the Golden Section, that ideal mathematical proportion, whose capacity to please the mind the Greeks discovered long ago. Painters through the years have used it freely in their works. To take a single artist, we could hardly do better than to choose the great Dutch abstractionist, Piet Mondrian, the geometry of whose paintings is singularly satisfying. (Fig. 11.) We stand here at the threshold of a subject I

shall pursue in the final chapter. For the moment, I want simply to argue that Mondrian's pictures satisfy us because they possess both physical and intellectual clarity and – this is the point – that we cannot enjoy the latter beauty without the former. I am sorry to report that Mondrian would have disagreed with me!

Continuing with our theme, let us now turn our attention to beauty in the world of nature. But before doing so, I should enter one qualification by quoting a statement of the Scottish philosopher, Norman Kemp Smith. Concerning those who believe in God, he wrote:

> In and through their religious experience of fellowship with God, they have
> belief in God, and coming to nature and history with this belief in their minds,
> they interpret nature and history freely in accordance therewith. They do not
> observe order and design, and therefore infer a Designer: they argue that order
> and design must be present even when they are not apparent, because all
> existences other than God have their source in him.[6]

If you will allow the terms 'order and design' to imply the word 'beauty' then you will understand the meaning of my qualification.

So, let us begin, once again, with Thomas Aquinas. At one point in his commentary upon Dionysius's work, *On the Divine Names*, Thomas declared, 'From the divine beauty the being of all things is derived'.[7] We recall the familiar dictum of St. Augustine, 'Whatever is, is good'. To it I would add, 'Whatever is, is beautiful'. The same God who imparts being and goodness to creatures imparts to them beauty as well. The works of the hands of Him who is Beauty itself, shall they not also be beautiful? Of course! God has bestowed upon them their own integrity, proportion, and brightness. They possess, in the broad sense of the term, form; that goes with their very existence. In its archaic usage the word 'form' meant beauty, as in the description of Isaiah's Suffering Servant, who lacked 'form or comeliness'. The total absence of form would result in the total absence of beauty. Prime matter (though I have never encountered it!) must be absolutely ugly.

Mention of ugliness does remind us that the creation only enjoys beauty in a diminished 'form'. It is not God; and ugliness has in fact invaded it. I remember John Baillie's once remarking in a lecture that we cannot look around us without concluding that the world is 'a good thing spoiled'. I hope he would not have objected to *my* saying that the world is a beautiful thing rendered ugly. Yet this judgement must not distract us from the fundamental conviction that whatever is, is beautiful. We must not allow Manicheanism to tempt us in an aesthetic guise. We can find the beauty of creation in the very midst of ugliness, and it is the beauty that matters. I can illustrate what I mean by appealing to an art other than painting or sculpture, to poetry. I have in mind the famous turning point of Coleridge's 'Ancient Mariner'.

> Beyond the shadow of the ship
> I watched the water-snakes;

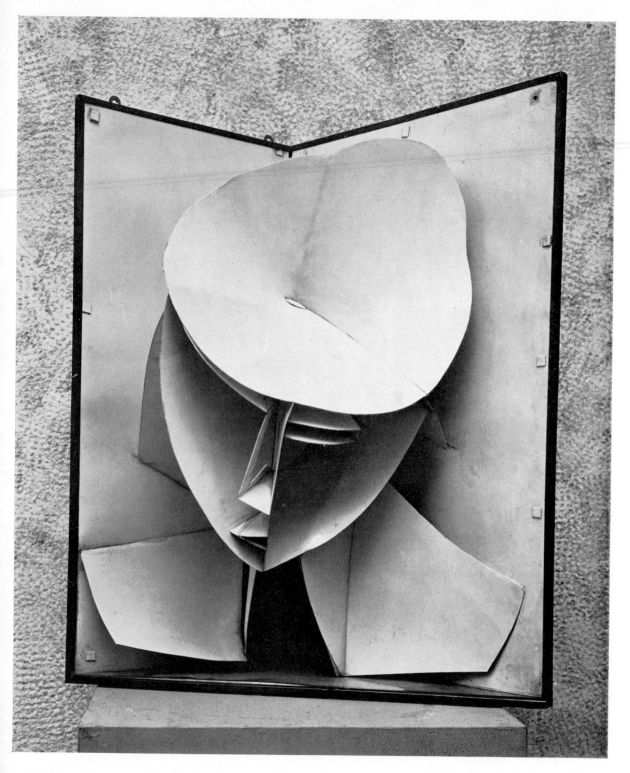

1. GABO, Naum. *Head of a Woman* (*c*. 1917–20, after a work of 1916). Construction in celluloid and metal, 24½″ × 19¼″. Collection, The Museum of Modern Art, New York. Purchase.

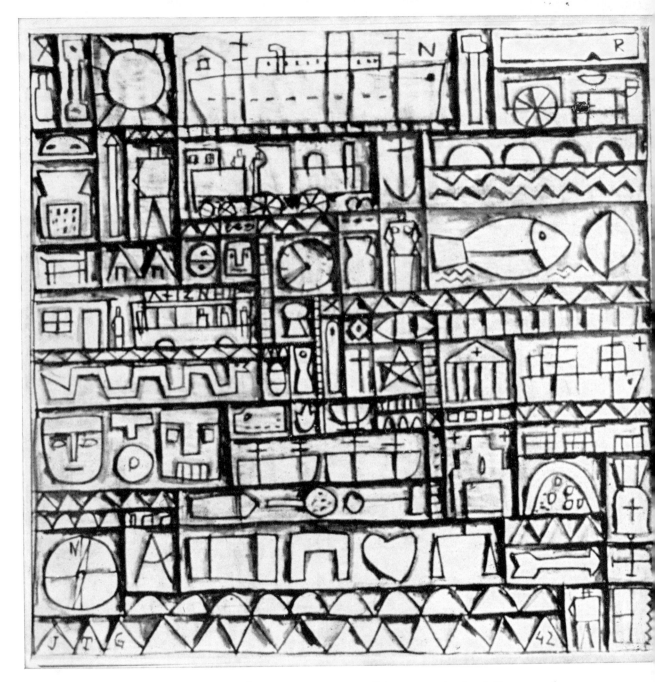

2. TORRES-GARCÍA, Joaquín. *Universal Constructivist Art*. Oil on wood, 1942, $60\frac{5}{8}'' \times 60\frac{3}{8}''$. Courtesy of the artist's family.

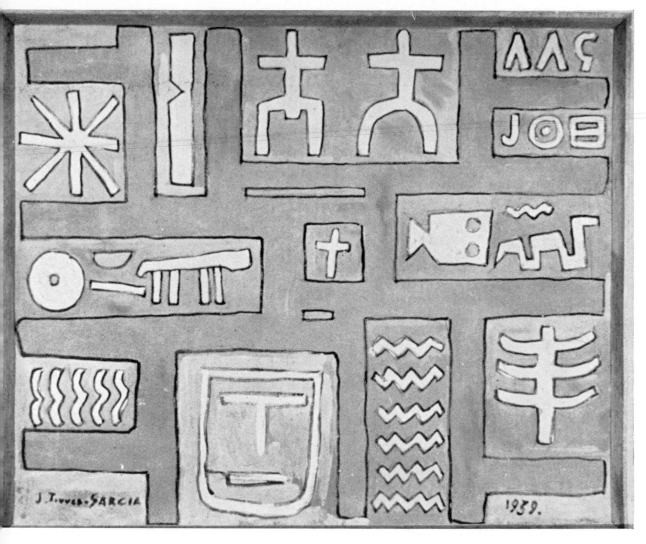

3. TORRES-GARCÍA, Joaquín. *Structure in Ochre with White Signs.* Tempera on cardboard, 1939, $34\frac{1}{8}'' \times 40\frac{7}{8}''$. Courtesy of the artist's family.

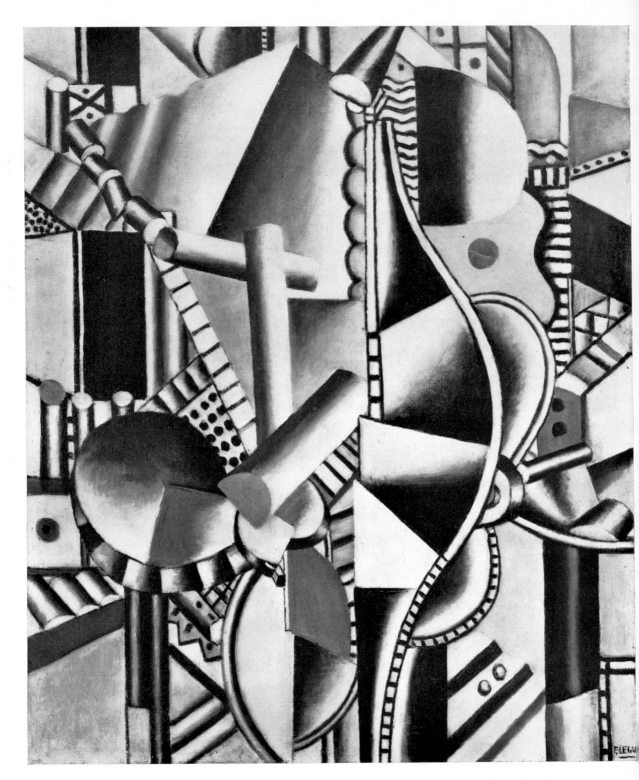

4. LÉGER, Fernand. *Propellers* (1918). Oil on canvas, $31\frac{7}{8}'' \times 25\frac{3}{4}''$. Collection, The Museum of Modern Art, New York. Katherine S. Dreier Bequest.

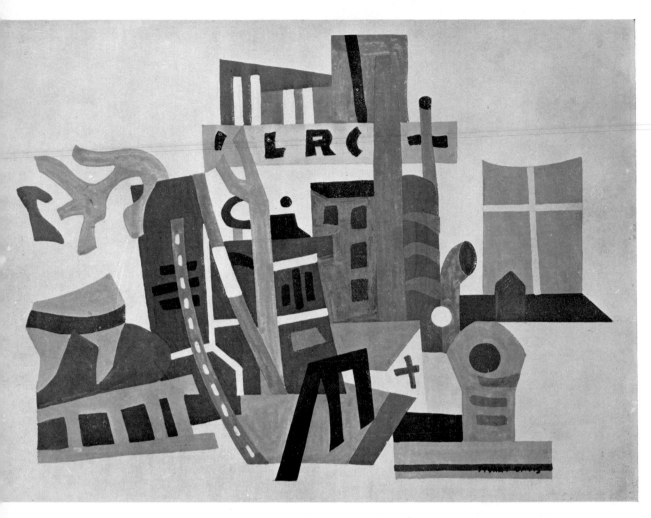

5. DAVIS, Stuart. *New York Waterfront* (1938). Gouache, $12'' \times 15\frac{7}{8}''$.
Collection, The Museum of Modern Art, New York. Given anonymously.

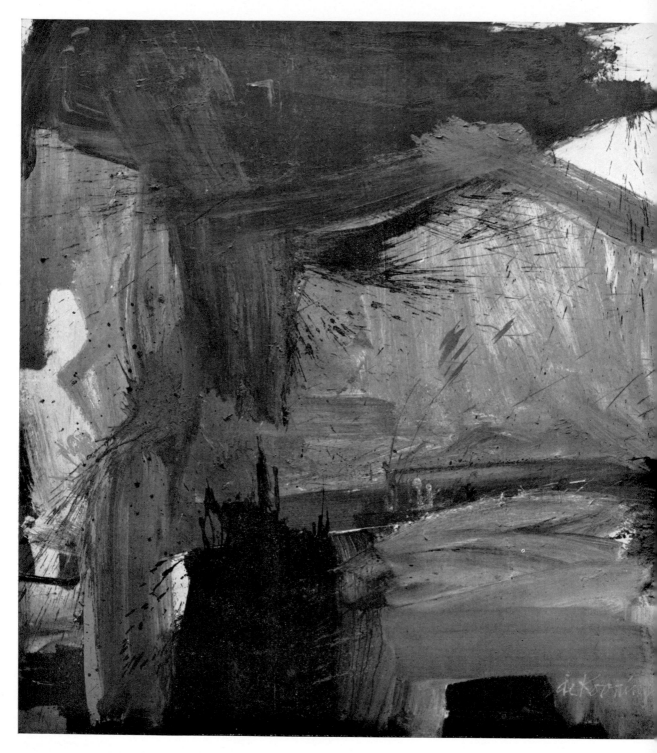

6. DE KOONING, Willem. *A Tree in Naples* (1960). Oil on canvas, 6′ 8¼″ × 70⅛″. The Sidney and Harriet Janis Collection, Gift to the Museum of Modern Art, New York.

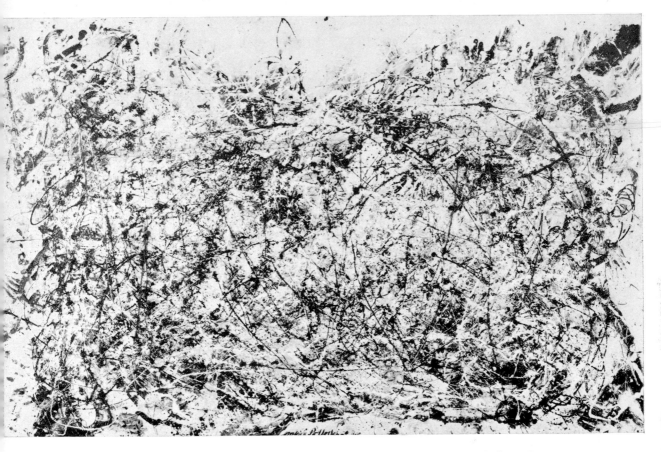

7. POLLOCK, Jackson. *Number 1* (1948). Oil on canvas, 68″ × 8′ 8″. Collection, The Museum of Modern Art, New York.

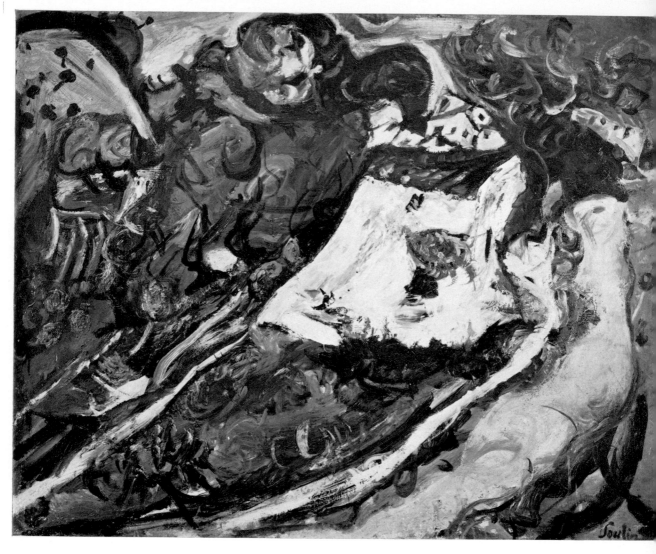

8. SOUTINE, Chaim. *The Old Mill* (*c.* 1922–23). Oil on canvas, $26\frac{1}{8}''\times$ $32\frac{3}{8}''$. Collection, The Museum of Modern Art, New York. Vladimir Horowitz and Bernard Davis Funds.

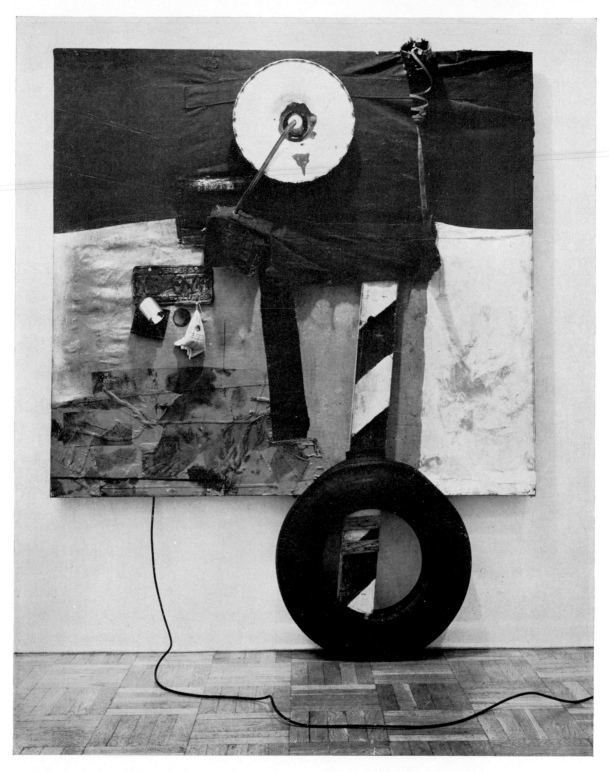

9. RAUSCHENBERG, Robert. *First Landing Jump* (1961). 'Combine-painting': tire, khaki shirt, license plate, leather straps, mirror, iron street light reflector, live blue light bulb, electric cable, steel spring, tin cans, various pieces of cloth and oil paint on composition board, 7′ 5$\frac{1}{8}$″ × 6′ 0″ × 8$\frac{7}{8}$″. Collection, The Museum of Modern Art, New York. Gift of Philip Johnson.

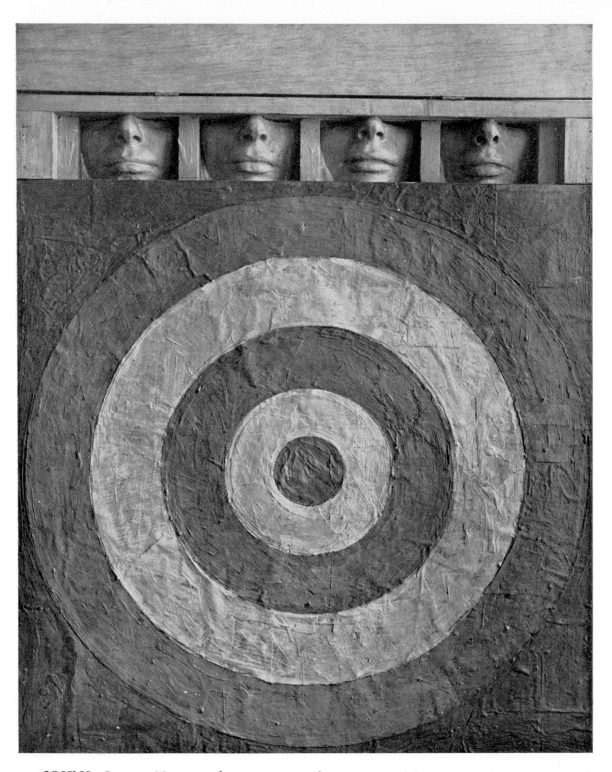

10. JOHNS, Jasper. *Target with Four Faces* (1955). Encaustic on newspaper on canvas, 26″ × 26″, surmounted by four tinted plaster faces in wood box with hinged front. Overall dimensions with box open, $33\frac{5}{8}″ \times 26″ \times 3″$. Collection, The Museum of Modern Art, New York. Gift of Mr. and Mrs. Robert C. Scull.

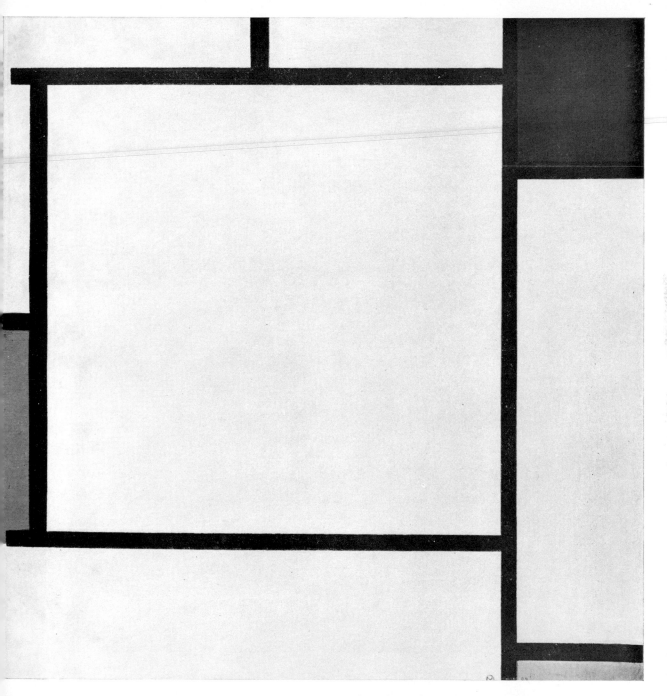

11. MONDRIAN, Piet. *Composition 2* (1922). Oil on canvas, $21\frac{7}{8}'' \times$
$21\frac{7}{8}''$. Collection, The Solomon R. Guggenheim Museum, New York.

12. SCHWITTERS, Kurt. *Merz 199* (1921). Tempera on paper and cloth collage, $7\frac{1}{8}'' \times 5\frac{5}{8}''$. Collection, The Solomon R. Guggenheim Museum, New York. Gift, Katherine S. Dreier Estate. Photo, Robert E. Mates.

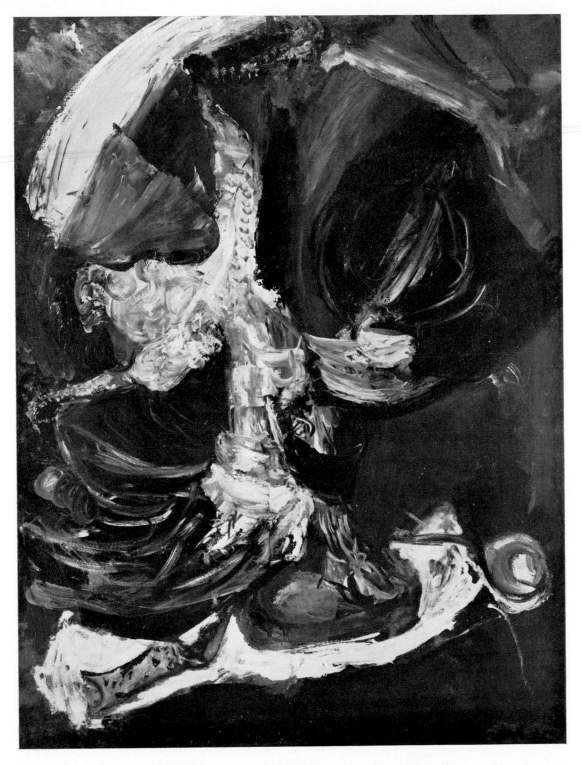

13. SOUTINE, Chaim. *Dead Fowl* (c. 1924). Oil on canvas, $43\frac{1}{2}'' \times 32''$. Collection, The Museum of Modern Art, New York. Gift of Mr. and Mrs. Justin K. Thannhauser.

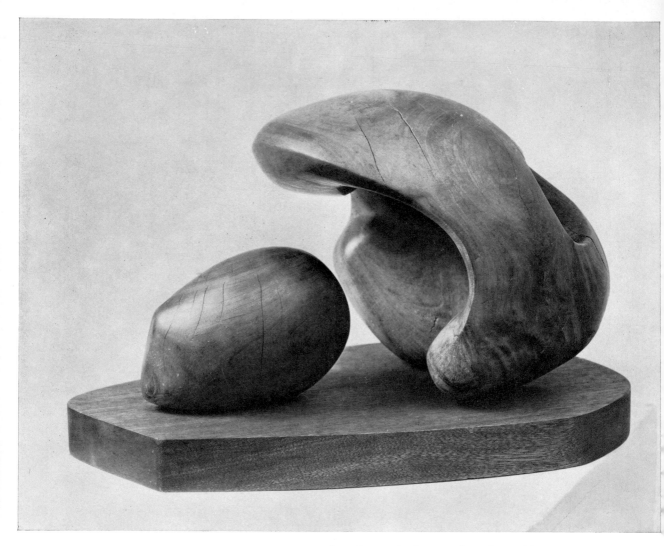

14. MOORE, Henry. *Two Forms* (1934). Pynkado wood, $11'' \times 17\frac{3}{4}''$ on irregular oak base, $21'' \times 12\frac{1}{2}''$. Collection, The Museum of Modern Art, New York. Sir Michael Sadler Fund.

15. Stone 'hacha'. State of Veracruz, Mexico (*c.* A.D. 800).

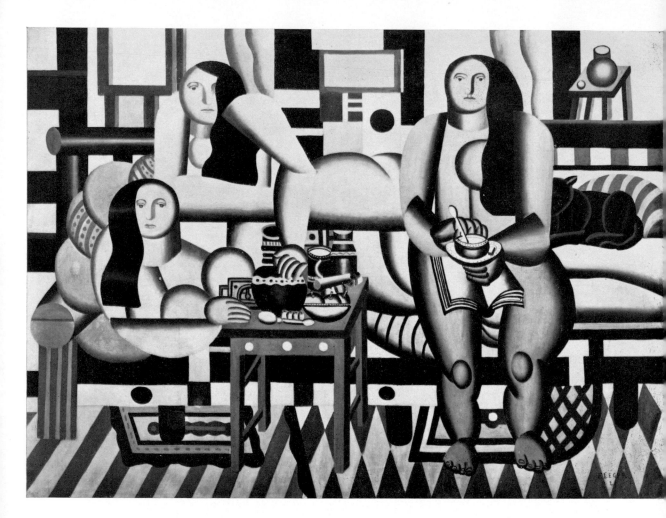

16. LÉGER, Fernand. *Three Women* (*Le Grand Déjeuner*) (1921). Oil on canvas, 72¼″ × 99″. Collection, The Museum of Modern Art, New York. Mrs. Simon Guggenheim Fund.

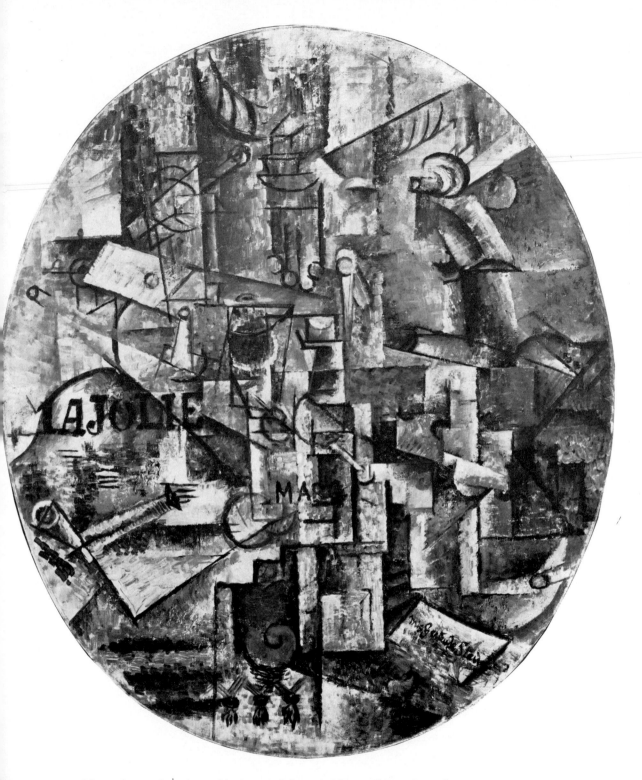

PICASSO, Pablo. *The Architect's Table (Ma Jolie).* $28\frac{5}{8}'' \times 23\frac{1}{2}''$ oval. Collection, The Museum of Modern
ing 1912.) Oil on canvas, mounted on panel, Art, New York. Gift of William S. Paley.

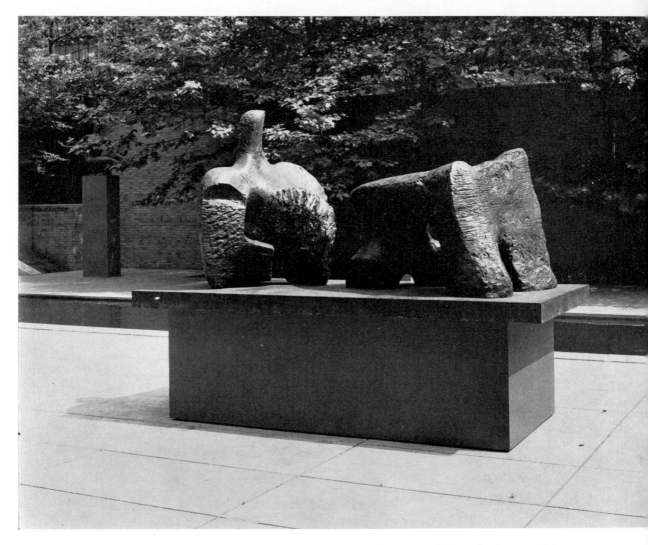

18. MOORE, Henry. *Reclining Figure, II (Two Parts)* (1960). Bronze, (a) 50″ × 34⅝″ × 29¼″; (b) 36⅝″ × 55¼″ × 41⅛″; overall length 8′ 3″. Collection, The Museum of Modern Art, New York. Given in memory of G. David Thompson, Jr., by his father.

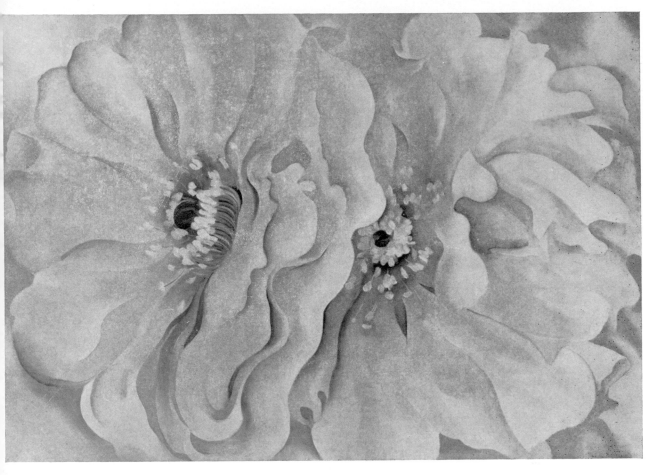

19. O'KEEFFE, Georgia. *Yellow Cactus Flowers* (1929). Oil on canvas, 29¾″ × 41½″. Collection of The Fort Worth Art Museum. Gift of the William E. Scott Foundation.

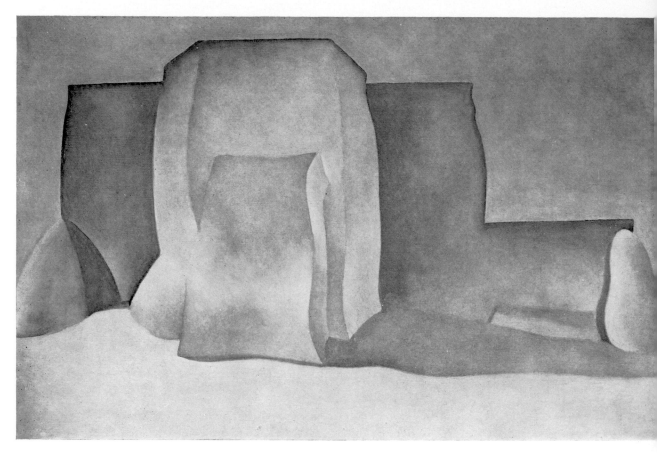

20. O'KEEFFE, Georgia. *Ranchos Church*. Oil on canvas, 24″ × 36″. Phillips Collection, Washington, D.C.

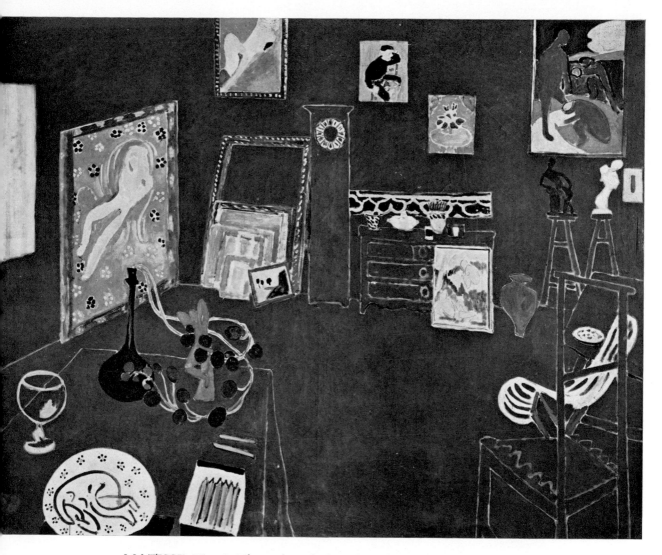

21. MATISSE, Henri. *The Red Studio* (1911). Oil on canvas, $71\frac{1}{4}''\times7'\ 2\frac{1}{4}''$.
Collection, The Museum of Modern Art, New York. Mrs. Simon Guggenheim Fund.

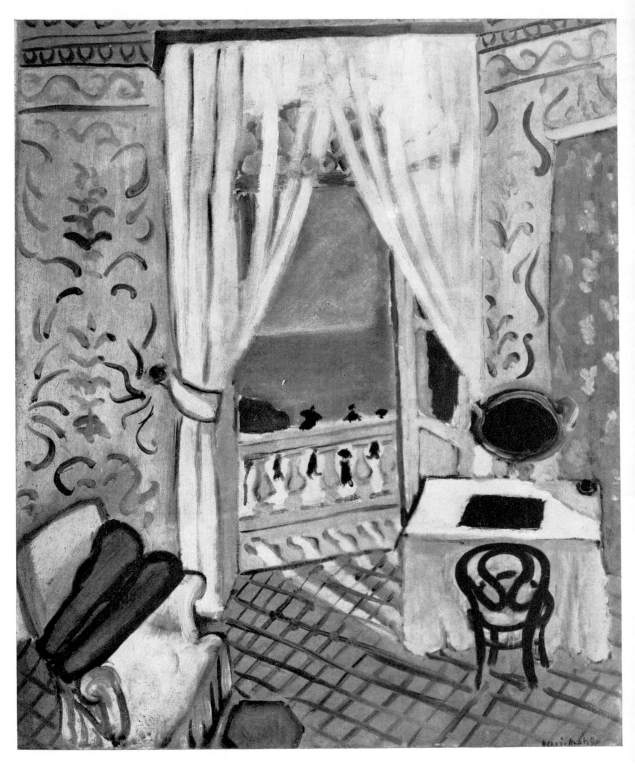

22. MATISSE, Henri. *Interior with a Violin Case* (1918–19, winter). Oil on canvas, $28\frac{3}{4}'' \times 23\frac{5}{8}''$. Collection, The Museum of Modern Art, New York. Lillie P. Bliss Collection.

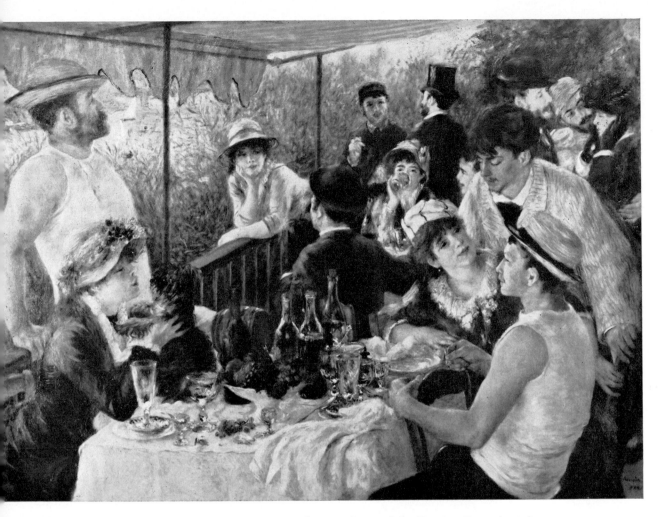

23. RENOIR, Pierre-Auguste. *The Luncheon of the Boating Party* (1881).
Oil on canvas, 51″×68″. Phillips Collection, Washington, D.C.

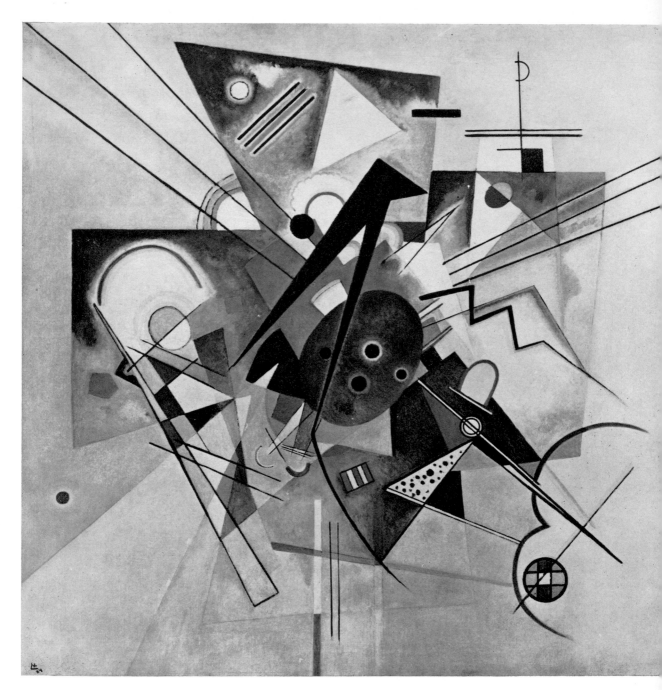

24. KANDINSKY, Wassily. *Yellow Accompaniment, No. 269* (1924). Oil on canvas, $39\frac{1}{4}'' \times 38\frac{3}{8}''$. The Solomon R. Guggenheim Museum, New York.

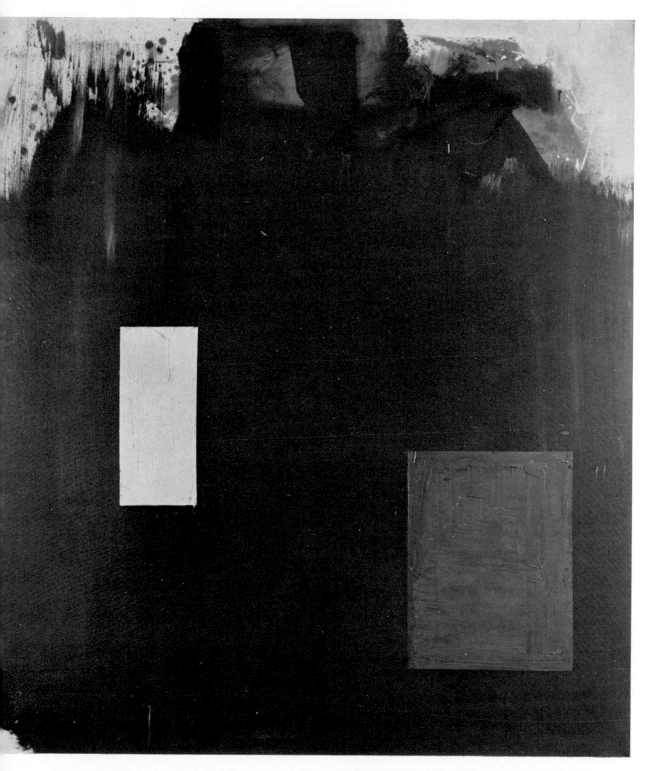

25. HOFMANN, Hans. *Memoria in Aeternum* (1962). Oil on canvas, 7′ 0″ × 6′ 0⅛″.
Collection, The Museum of Modern Art, New York. Gift of the Artist.

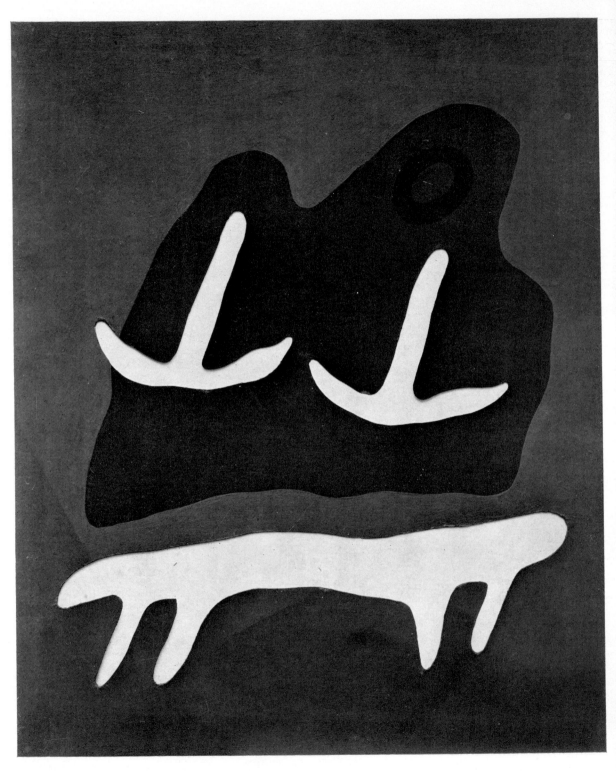

26. ARP, Jean. *Mountain, Table, Anchors, Navel* (1925). Oil on cardboard with cut-outs, $29\frac{5}{8}'' \times 23\frac{1}{2}''$. Collection, The Museum of Modern Art, New York. Purchase.

27. De KEUNINCK, K. (?) *The Good Samaritan*. Oil on copper. Dutch, early seventeenth century.

28. RENOIR, Pierre-Auguste. *Bal à Bougival*. Oil on canvas, 70″ × 34″.
Courtesy, Museum of Fine Arts, Boston. Purchased Picture Fund.

They moved in tracks of shining white,
And when they reared, the elfish light
Fell off in hoary flakes.

Within the shadow of the ship
I watched their rich attire:
Blue, glossy green, and velvet black,
They coiled and swam; and every track
Was a flash of golden fire.

O happy living things! no tongue
Their beauty might declare:
A spring of love gushed from my heart,
And I blessed them unaware:
Sure my kind saint took pity on me,
And I blessed them unaware.

And with that the albatross slips from the Mariner's neck and sinks into the sea. I am not here to defend the Romantics' tendency to endow nature with human traits; nor do I think that Coleridge falls into that trap. But I do endorse the belief that, however dim and diminished, beauty always gleams in the creation, and we can find it. Such discernment accords well with the biblical efforts to draw man's attention to the natural world and the beauty it displays. Surely it is because of their beauty that the heavens declare the glory of God. It is for their beauty that Jesus tells his disciples to regard the lilies of the field. And it is for its beauty that the pearl is of inestimable worth.[8]

In the entire world of nature nothing beautiful has so entranced the minds of men as the beauty of the human figure itself. At first blush it is therefore baffling to find in the New Testament no physical description of Jesus Christ. The silence of the Gospels – what does it imply? Were the authors, to say nothing of the traditions on which they drew, simply uninterested in this matter? Or was Jesus Christ, in his appearance, so unprepossessing that a description of him would have lent no credence to the claim that he was Lord? The problem somewhat embarrassed the early Church, and it eventually sought an easy way out by depicting Jesus not as the obscure man of Nazareth but rather as the heavenly Lord, risen, ascended, and seated in glory. But I do not believe we have to settle for that solution and I have theological objections to it that, I hope, will become apparent in due course. To be sure, all our evidence is indirect but it does suggest an answer. I should myself take quite seriously Isaiah's declaration that the Suffering Servant possesses neither beauty nor comeliness. At least Isaiah himself is most emphatic. The passage from the fifty-third chapter is rendered thus in the New English Bible: '. . . he had no beauty, no majesty to draw our eyes, no grace to make us delight in him; his form, disfigured, lost all the likeness of a man, his beauty changed beyond human semblance'. Isaiah leaves no doubt:

the Servant is ugly, if not downright repulsive! I am not prepared to go quite to such lengths as that. But in my own thinking I set Isaiah's description alongside the verbal picture that the Old Testament gives us of the children of Israel as the least of all the peoples of the earth, those who 'apparently' have nothing to recommend them as God's chosen ones. As that snatch of doggerel has it: 'How odd of God to choose the Jews'. And maybe it is quite true that he chose them for the very reason that they lacked all qualifications, so that they would have no excuse for glorifying themselves, instead of Him. That is another issue. My own contention is that if we take seriously the witness of the Old Testament we have no reason to suppose that Jesus, the chosen *One*, could have been anything *but* unprepossessing in his appearance. No urgent physical beauty sprang out to grasp those who saw him. We may not wish to suppose him ugly; perhaps we should call him 'obscure'. And that is not a bad word, because the appearance of Jesus veils the beauty of God, which just does not lie on the surface, naked and stunning in its splendour. Yet those who have looked upon the face of Jesus have indeed seen God in his beauty, and the experience transforms their way of seeing.

I suggest that it ought to transform *our* way of seeing. I have said as much already in my comments on beauty and ugliness in the creation. They were meant to anticipate what I am saying now about Jesus Christ. Perhaps the discerning reader has already observed that I was working backward; at least I gave warning in that quotation from Kemp Smith! The creation exists for the sake of Jesus Christ. He is its master and interpreter and he employs it as the setting for the establishment and development of his own covenant. He enters it in obscurity but claims it nevertheless. As Kierkegaard's parable reminds us, the prince woos his beloved in the guise of a peasant; yet a prince he remains, even when his splendour and beauty are concealed beneath his disguise. So are they also concealed in the creation that belongs to him. But they are there – and they *are* his.

When it comes to art – we have at last got there! – I should advance a similar claim. The beautiful objects that men make bear their own testimony to Jesus Christ. The point is complicated, because we have not yet considered the relationship between nature and art. That in fact is the theme of the next chapter, so I am not mentioning the subject only to drop it. At least here it can be said that art quite often reflects the ugliness of the world. In his discussion of beauty Thomas Aquinas argued, however, that 'an image is said to be beautiful, if it perfectly represents even an ugly thing'.[9] Harmony, that second condition of beauty, still prevails. Art, on the other hand, is not simply an imitation. If it were only that, we should have to adopt Plato's position. But it is more than that, as I shall try later to show. At any rate, art often *does* exhibit some ugliness from that world out of which it arises and within which it is made. But, as with nature, it is the beauty that counts, the form and the clarity.

Let me appeal to two artists of our century, whose works illustrate the point. The first is Kurt Schwitters. (Fig. 12.) Schwitters was a German, who lived much of his life in Hannover and who created his finest work in the years just following the First World War.

In the main, they are collages. To compose them, Schwitters combed the postwar rubble heap of Europe and emerged with, literally, scraps, out of which he constructed these collages. They display bits of wood and wire, segments of pictures, and, especially, printed matter such as tramway ticket stubs and pieces cut from a newspaper. The net result is a triumph of order, of beauty raised from chaos. These collages achieve, in the words of one scholar, 'an air of almost classical isolation'.[10] The individual parts are nothing if not ugly, mere refuse, the sweepings of the street. But the artist has combined them in such fashion as to produce beautiful objects.

The second artist I have in mind worked with ugliness of a different sort. He is the Lithuanian-French painter, Chaim Soutine, and his chief struggle was with the chaos of his own psyche. (Fig. 13.) To be sure, it found external expression in his style of life. For example, as a model he might take a dead fowl and hang it in his studio, where, as he painted it day after day, it progressively became more rotten, until in time the neighbours complained about the odour! But Soutine's great achievement was, in his paintings, to wring order from his own internal torment. They do not hide the *dis*order of his own mind; but they incorporate it and overcome it in beautiful forms that manifest the integrity, harmony, and brightness of which St. Thomas wrote. Both these men – Schwitters and Soutine – demonstrated the courage to face ugliness, each in his own way, but to dominate it by their creative power. As one scholar has written, art 'can be an anguished hymn sung in the shadow of nothingness, for it is analogical to God's creation *ex nihilo*'.[11] In the realm of art, this creation is, *par excellence*, the creation of beauty, the bestowal of form. Ernst Cassirer once remarked that art cannot emerge from a plunge into the irrational and formless. It is the Romantic fallacy to suppose that it can. The vision of the artist may indeed be bizarre and grotesque, as may be the work that he makes. But both vision and object still possess a structure, a form, 'a character', says Cassirer, 'of rationality'.[12]

Without such a formal character, a work of art would not please. The Middle Ages produced a very succinct definition of the beautiful: '*id quod visum placet*', 'that which pleases the eye'. And in art, it has been traditionally thought in the West, that which pleases the eye is above all the ' "good" Gestalt', that harmonious and serene composition, which Sir Herbert Read cited. It is epitomized in the human figures of classical Greek statuary. But in our own century many artists have rebelled against what we might call the 'tyranny' of beauty and they have appealed instead to a different principle of determination in art – the principle of power.

One of the chief spokesmen for this viewpoint is the English sculptor, Henry Moore. As early as a trip he made to Italy in 1926, Moore had singled out Greece as the enemy. He wished to discard the Greek insistence on representation in sculpture and try, if he could, to capture the emotional intensity that he believed to be resident in individual shapes and forms. Several years later he himself wrote: 'In sculpture the later Greeks worshipped their own likeness, making realistic representation of much greater importance than it had been at any previous period. The Renaissance revived the Greek ideal

and European sculpture since then, until recent times, has been dominated by the Greek ideal'. But now the 'Greek spectacles' have been removed from the eyes of modern sculptors, who thus are able once again to realize 'the intrinsic emotional significance of shapes instead of seeing mainly a representation value. . .'. (Fig. 14.) This deliverance, moreover, frees them to deal honestly with their material. They 'know that sculpture in stone should look honestly like stone, that to make it look like flesh and blood, hair and dimples is coming down to the level of the stage conjuror'.[13] 'Between beauty of expression and power of expression', Moore continues, 'there is a difference of function. The first aims at pleasing the senses, the second has a spiritual vitality which for me is more moving and goes deeper than the senses.'[14] Thus art shrugs off its 'perfectionist' bonds and regains vitality, the very quality of life, in contrast to the quality of the ideal.

It is worth asking whether we must really make this choice between beauty and power. Is it necessary? Or is it a false antithesis? Must the two stand in conflict? Moore is himself not thinking of power in raw and unrestrained form. 'The great, the continual, everlasting problem (for me)', Moore writes, 'is to combine sculptural form (POWER) with human sensibility and meaning, i.e. to try to keep Primitive Power with humanist control.'[15] He means, in a word, power shaped to form, pent up, as it were, within the defined mass of his sculpture. A statue by Henry Moore or, for that matter, a work of art by any other artist who shares his point of view need not, it seems to me, fall outside that Medieval definition of the beautiful as 'that which pleases the eye', just because the work first of all embodies power. The Greek aesthetic canon was doubtless too restrictive and over the years lost its own vitality. It required a particularly strenuous effort on the part of Moore and others to unburden themselves of this heritage. There is thus historical justification for the sharpness with which Moore sometimes draws the contrast between beauty and power. But the time has come to nudge the two closer together.

Perhaps they have never really been so far apart. The fascination that artists of our era, like Moore, have shown with power springs partly from their exposure, earlier in this century, to primitive art, the art of Oceania, Africa, and Pre-Columbian Middle America. The last exercised especially strong influence upon Moore. But I wish to draw attention to some remarks made by Henri Matisse in the course of discussing a Javanese stone head. In 1912 a lady journalist, an American named Clara T. MacChesney, held an interview with Matisse. In the course of it the painter 'picked up a small Javanese statue with a head all out of proportion to the body. "Is not that beautiful"? "No", I said boldly [Ms. MacChesney speaking]. "I see no beauty when there is lack of proportion. To my mind no sculpture has ever equalled that of the Greeks, unless it be Michael Angelo's"'. Then Matisse replied in words that Henry Moore would certainly applaud:

> But there you are, back to the classic, the formal. . . . We of today are trying
> to express ourselves today – now – the twentieth century – and not to copy
> what the Greeks saw and felt in art over two thousand years ago. The Greek
> sculptors always followed a set, fixed form, and never showed any sentiment.

The very early Greeks and the *primitifs* only worked from the basis of emotion, but this grew cold, and disappeared in the following centuries. It makes no difference what are the proportions, if there is feeling. And if the sculptor who modeled this makes me think only of a dwarf, then he has failed to express the beauty which should overpower all lack of proportion, and this is only done through or by means of his emotions.

Above all . . . the great thing is to express one's self.[16]

It might be well for me to comment first upon Matisse's references to proportion, since that word denominates Thomas's second condition of beauty. Matisse has discovered that pleasing proportion is not necessarily that perfect anatomical proportion that characterizes Greek sculpture. A statue may be 'proportioned' in accordance with the emotions of the artist and thereby lose nothing in beauty. It maintains its harmony even when, for the sake of emotion, it distorts the relationship of head to body or of leg to torso. Proportion, as a condition of beauty, does not depend upon faithful imitation of natural forms. In this case it depends upon both the intensity and the control that the artist imposes upon his work.

I would like to illustrate this point with an anecdote of my own that concerns a piece of Pre-Columbian sculpture. (Fig. 15). It is an axe-shaped figure (and therefore called an 'hacha', after the Spanish word for axe) from what is now the Mexican state of Veracruz. Twice I viewed this piece in the company of two different men, each of them an expert on such art. Both were very impressed with the hacha. But the first said, 'Of course, it's ugly as hell'! while the second said, 'It's absolutely beautiful'! I am not playing a game when I maintain that both men were quite right. The first, at least within the context of his remark, was speaking as a Greek, because the statue *does* distort human proportions in an expressive, not to say grotesque, way. But the second was speaking from a viewpoint such as that of Matisse, for the controlled power of the figure *is* remarkably beautiful.

It therefore seems to me that art need not surrender beauty for the sake of conveying power. But the main reason I say this is not because of my experience with the hacha. It is because I do believe that painting and sculpture are God's gifts and because I am sure that, as such, they reflect in their own nature the being of that God who himself sacrifices neither his beauty to his power nor his power to his beauty. Power, after all, is another of his perfections and one with which we are more familiar, theologically, then we are with beauty. And if beauty is customarily appropriated to the Word, so power is to the Father. ('I believe in God the Father – *almighty*. . . '.) But I propose doing something different. Let me first say that the theological act of appropriating a given perfection to one member of the Trinity does not imply its denial to the others. So, I am leaving myself an escape hatch! But what I should do, as a theologian now, is to appropriate power to the Holy Spirit.

I am sure that such a step is much more familiar in Eastern Christendom. The Orthodox

Church is accustomed to viewing the Spirit as the source of surging power, who shakes and shatters in awesome and unpredictable ways. But the Western Church as well has not been oblivious to the powers of the Spirit, though the theology has remained quite incomplete. It is the Spirit who brings power to the disciples and to the Church. It is he who strengthens and builds up, directs and inspires the Christian community. On this issue the difference between East and West certainly stems from the difference over the procession of the Spirit.[17] While the East has consistently maintained the Spirit's procession solely from the Father, the West has hewn to the *filioque*, to the double procession of the Spirit from Son as well as from Father. Detached theologically by the Eastern Church from his bond to the Word, the Spirit is thus detached from that member of the Trinity who stands for order, rationality, and beauty. Under these circumstances, it is much easier to regard the Spirit as freely moving power, who blows where he lists. In the West, such an option is unavailable, for the very reason that the Spirit is yoked not only to the Father almighty but also to the intelligible Word, whom I have associated, for purposes of this chapter, with the divine beauty.

Western Christians invariably understand the Spirit as the very Spirit of Jesus Christ, the Word incarnate. The Spirit's power is not unrestrained strength. It is instead the power by which we receive the fruits of Christ's work. It is a power, then, informed by the beauty of the Redeemer. I myself find this union of beauty and power tellingly expressed in one of the Church's hymns, 'O Spirit of the Living God'. The second stanza ends, 'Give power and unction from above, when-e'er the joyful sound is heard'. And the third stanza immediately adds, 'Be darkness, at thy coming, light; confusion, order in thy path'. We do not ordinarily regard art as a confirmation of the double procession of the Spirit; but it is, nevertheless.

NOTES TO CHAPTER 4

1. Martin Luther, *Lectures on Galatians*, Jaroslav Pelikan (ed.), *Luther's Works*, Vol. 26 (Saint Louis: Concordia Publishing House, 1963), 129f.
2. Thomas Aquinas, *Summa Theologica*, Fathers of the English Dominican Province (trans.), Vol. 1 (New York: Benziger Brothers, Inc., 1947), Ia, q. 39, art. 8.
3. Origen, *On First Principles*, G. W. Butterworth (trans.) (New York: Harper & Row, 1966), 21f.
4. Isak Dinesen, *Out of Africa* (New York: The Modern Library, 1952), 7.
5. Étienne Gilson, *Painting and Reality* (New York: Pantheon Books, 1957), 254.
6. Quoted in Louis Dupré 'The Argument of Design Today', *The Journal of Religion*, Vol. 54, No. 1 (January, 1974), 11f.
7. Quoted in Maritain, 31.
8. Cf. Julian N. Hartt, *A Christian Critique of American Culture* (New York: Harper & Row, 1967), 85.

9. Thomas Aquinas, Ia, q. 39, art. 8.
10. William S. Rubin, *Dada and Surrealist Art* (London: Thames and Hudson, 1969), 102.
11. David Baily Harned, *Theology and the Arts* (Philadelphia: Westminster Press, 1966), 142.
12. Ernst Cassirer, *An Essay on Man* (New Haven: Yale University Press, 1944), 167.
13. *Henry Moore on Sculpture*, Philip James (ed.) (London: Macdonald, 1966), 57.
14. *Ibid.*, 72.
15. *Ibid.*, 74.
16. *Matisse on Art*, Jack D. Flam (ed.) (London: Phaidon, 1973), 52.
17. I am grateful to Hans W. Frei for making this point to me.

Chapter 5

Art's Subdual of Nature

'NOW THE DISCOVERY or systematic transmission of the arts, or the inner and more excellent knowledge of them, which is characteristic of few, is not sufficient proof of common discernment. Yet because it is bestowed indiscriminately upon pious and impious, it is rightly counted among natural gifts. . . . Meanwhile, we ought not to forget those most excellent benefits of the divine Spirit, which he distributes to whomever he wills, for the common good of mankind. . . . It is no wonder, then, that the knowledge of all that is most excellent in human life is said to be communicated to us through the Spirit of God'.[1] With these words Calvin expresses his conviction that all human gifts, those of unbelievers no less than those of believers, are endowments of the Holy Spirit. No sentimentalist, Calvin of course added that the impious hold down their truth in unrighteousness – but it is truth nevertheless. In his liberality, God has bestowed upon all humans the opportunity and the mandate to subdue the creation. Men proceed to this task in manifold ways, but of course the particular way of concern here is the making of art, a human enterprise that, it strikes me as a theologian, may perfectly well be understood as an aspect of human subdual of nature. To be sure, unbelievers share in this pursuit, and on that score I am no more sentimental than was Calvin. *They* hold down this truth in unrighteousness. But they do hold down *this truth*, and therefore it is a fit topic for theological consideration. Our course is somewhat eased by reason of the fact that almost all artists, whatever their religious persuasion (or lack thereof), harbour *some* idea of the relationship between their work, on the one hand, and the creation, nature, on the other hand.

It was Plato's contention that art is nature's imitator. I cite this view because I want to dispel it. For generations, for centuries, artists have themselves protested against it. They have denounced the idea that they merely transcribe nature and they steadily insist that they add something *to* nature. *What* they add we shall have to consider and we shall see that the answer is not uniform. But the artists have rightly sensed that the subdual of nature (to use that theological phrase) is not the sheer representation of it. Such a view finds expression in certain poetry:

> Once out of nature I shall never take
> My bodily form from any natural thing,

But such a form as Grecian goldsmiths make
Of hammered gold and gold enamelling
To keep a drowsy Emperor awake;
Or set upon a golden bough to sing
To lords and ladies of Byzantium
Of what is past, or passing, or to come.[2]

While 'Sailing to Byzantium', Yeats indulged in a bit of exaggeration, because even the bodily form of a golden bird takes *something* from nature. (As we all know, however, exaggeration is the poet's prerogative – even if it is not the theologian's!) The same point is made by one of the greatest painters of our century, Paul Klee, who began his 'Creative Credo' by affirming quite bluntly, 'Art does not render the visible; rather, it makes visible'.[3]

While art is thus distinct from nature, its union with nature has not dissolved. Through the centuries philosophers as well as artists have testified to this union, though they have conceived it in different ways. But somehow or other the artist draws upon nature for his raw material, which, subsequently, he forms in accord with his own vision. Did he not engage in this subjective shaping of the material, we would be back with art as imitation. But without the material, the artist would produce nothing, or else be God, since God alone is able to create something from nothing. Therefore, as Cassirer maintains, 'the artist dissolves the hard stuff of things in the crucible of his imagination, and the result of this process is the discovery of a new world of poetical, musical, or plastic forms'.[4] In the case of plastic forms, the utter newness of such a world reveals itself most forcefully in the abstract painting of our own century. Confronting one of Mondrian's pictures we find it resembling nothing previously seen on earth, perhaps not even in heaven. Yet this newness does not contradict our claim that the artist always begins with nature. In a letter of January 29, 1914, Mondrian wrote to the art critic, H. P. Bremmer: 'I construct line and color combinations upon a flat plane with the aim of giving form . . . to *general* [principles of] *beauty* in the most consciously possible manner. Nature (or that which I see) inspires me and provides me, as it does every painter, with the emotional stimulation through which the creative drive occurs.'[5] And James Johnson Sweeney, one of the most perceptive students of modern art, has described abstract painting as a 'metaphor of structure – essentially an organization of color-relationships, line-relationships, and space-relationships recalling to the conscious, or unconscious mind some basic, organic relationship in Nature'.[6] The artist thus emerges as the *re*-creator of nature, the one who 'subdues' it in a vast and frequently bewildering variety of forms, but the one who subdues, precisely, nature.

As I have suggested, we can find no uniform manner to this subdual nor to the exact relationship that obtains between the artist and his material, nature. Our own century has cast up quite a few interpretations, some of which I judge to be without precedent. I want to spend the remainder of this chapter examining several of them. By the time I am

finished, the reader will know the one upon which, for whatever it may be worth, I should confer my own theological imprimatur!

We begin with those who consider art an escape from nature, the pathway to a new creation, whose lineaments are of a softer, gentler, and more ethereal contour. If, like Omar, they wish to 'grasp this sorry Scheme of Things entire . . . and then Re-mould it nearer to the Heart's Desire'! their hearts desire a gossamer and filmy scheme of things, dominated by an intense stillness, through which figures dreamily float in defiance of the law of gravity, to say nothing of all those other tough and intractable laws that govern this creation. I am speaking, of course, of the Symbolist painters, who, with their counterparts in poetry, had their day around the turn of this century. One of their number is the American painter, Arthur B. Davies, and a verbal picture of his art is provided by another American, the present-day critic, Harold Rosenberg, who writes, 'The silent landscapes in which [Davies] posed his familiar penumbral nymphs are, like Symbolist art generally, a refuge, contrived from the history of art, beyond the reach of events'. Davies's canvases, Rosenberg adds, are 'closed gardens'.[7] That phrase – 'closed gardens' – calls to mind the 'Madonna and Child in a Rose Garden' by the fifteenth-century German painter, Stefan Lochner, wherein Mary and the infant Jesus inhabit a garden of weightless and dreamy atmosphere, *toto caelo* remote from the natural order in whose dense dimensions we live. It is, quite literally, 'out of this world'. The vision of the Symbolists or of a Lochner has not commended itself to our mundane and time-bound era. Nor does it commend itself, theologically, as adequate human response to the divine injunction to subdue creation. Escape is not subdual, but this option has presented itself, and no doubt we shall see it again.

The Constructivists, whose art and programme were previously examined, view nature in another light. To them, it is neither congenial nor hostile but simply indifferent. This attitude follows from their determination to be 'scientific' in all matters. If one were to object that their art is devoid of human emotion, they would respond, in the words of one scholar, that such a view 'seems to presuppose a lingering adherence to the "pathetic fallacy" of the romantics', who felt 'that external phenomena exist to provide a kind of sympathetic sounding board to human feeling, and that the artist should try to re-create this resonance in his work. What can be stated quite categorically about constructivism is that it rejects the comfortable assumption of a "given" harmony between human feeling and the outside world. In contrast, it implies that man himself is the creator of order in [the] world . . . and that the artist must play a central role in determining the type of order that is imposed'.[8] Thus one subdues nature through dispassionate investigation, rigorous and scientific in its character. Like the scientist, the artist pursues an inductive method, gathering data from which he may deduce laws for the construction of his art. His work will then be united to nature in principle but it will be opposed to nature in expression.[9] The painter, Theo van Doesburg, even insisted, 'The work of art must be entirely conceived and formed by the mind before its execution'.[10] Now, in another

respect, the artist becomes God, not this time because he creates something out of nothing, but rather because he possesses in advance a full and complete vision of the object that he will make. Ordinarily, artists have not ascribed to themselves such prescience, if only because they recognize all too well the recalcitrance of the materials with which they work.

Indeed, not all the Constructivists display such a sanguine confidence in their powers. While man may constitute the zenith of nature's evolutionary process and while he may bend all else to the service of his will, it is equally true that science has removed his little earth from the centre of creation and has struck from his head creation's crown. In the words of Naum Gabo, man is not 'the only hero of the cosmic drama'.[11] Nevertheless, in art itself man has asserted his superiority over nature. He is no longer limited, as he was in the past, to the forms that nature itself provides, re-make them however he might. He has now been able to invent the content of his art, imitating not nature's results but instead nature's method. He creates, let us say, a sphere, which in its three dimensions enjoys fully as much reality as an apple, but it is in no way restricted to the form of an apple.[12]

This stance of the Constructivists implies that art, so long as it is dependent upon nature's forms, must engage in competition with nature upon the ground of nature itself, upon, that is, alien ground, controlled by the opponent.[13] To the Constructivists, proof of their (and hence man's) triumph lies in the removal of the battle to their own field, upon which they can exercise domination over nature. The subdual of nature issues ultimately in its exploitation, its exploitation purely for whatever purposes man cares to use it. As nature bears no link to God, man is not responsible to God for the subdual of creation. As nature's master, he need answer only to himself. Obviously, the 'deconsecration' (if I may call it that) of nature is a process that has been developing for a long while, but it achieves an unusually sharp focus in the thought and in the art of the Constructivists, who, to this extent, are true children and representatives of our secular age.

I said earlier that the social programme of these artists, if not their vision, ended in failure, as was also the case with painters like Léger and Stuart Davis. The crises of society proved too vexing and tenacious. With that recognition, many artists turned within themselves to find the resources to pursue their work. That was the exact move taken by the Action Painters in the United States, who, you recall, fought their emotional battles with paint upon canvas. The artistic burning point still lies in nature, but in the subjective nature of the artist himself. That of which *he* is made determines that which he shall make, and the opposite is equally true, for in the process he creates himself. The artist is struggling to subdue his own nature, to gain (if the term is not too overworked) his own identity. At the very least he is trying to express that identity, but I should say that the definition of it is also involved, and that accounts for much of the passion with which these artists attacked their work. As Cassirer reminds us, it is out of cultural labour that persons emerge, that 'I' and 'Thou' take shape,[14] and we witness in these paintings the strenuous gestation of a human being, the consolidation of a person. The American painter, Edward

Hopper (who was not a member of this group, however), once replied, when asked what he was after in a certain picture, 'I'm after me'.

It is probable that self-discovery is an element in the work of all artists, however 'impersonal' their art may seem. The Action Painters were peculiarly conscious of this element, and it is for that reason that their work exhibits it so directly. I should myself regard it as another feature of that subdual of nature, which is our theme. And I take the artist's capacity to engage in this form of subdual as an unusually potent endowment of God. To forge one's identity, to become a person, is at best a tender, prolonged, and agonizing business. To pursue it consciously, through the making of paintings or sculpture, brings it to a virtually unmatched intensity, where we see take place unveiled that fight for sanity, of which Sir Herbert Read spoke. And to us, as witnesses, the sight provides its own challenge to struggle toward the formation of our own selves. The artist's endowment, his gift from God, extends its benefits to us, engaged as we all are in the effort to subdue our own natures. The human response to art is, however, the topic reserved for our last chapter.

The Constructivist attitude toward nature, which we have already examined, received at the hands of Fernand Léger a more tempered, less ideological statement. In common with most artists of his generation, Léger wished to free art from its captivity to the beautiful forms of nature, epitomized by the human figure. Like Henry Moore, he denounced this 'Greek' view and he launched an attack upon the 'subject', by which he meant nature's 'results' (to use a term employed earlier). To Léger, the sixteenth century, the High Renaissance, perpetuated the decadence into which Greek art had fallen. It is the time, he argued, of two great errors: the spirit of imitation and belief in the beautiful subject.[15] He is prepared to claim that 'nature', as the Academicians speak of it, does not exist. Each person sees this nature through his own eyes and thus his grasp of it is incurably subjective.

But Léger found the experience of seeing profoundly altered in the twentieth century and the artist's position correspondingly more complex. What the artist now sees is far, far more fluid, and he has many more sensory impressions to register and take into account. For example, he may travel at great speed in a train across the countryside and watch nature flicker by in perpetual motion. (It is no accident, incidentally, that the cinema fascinated Léger.) Forms are broken up in our own experience. Why complain when the artist breaks them up on his canvas? Or, to take another instance; the artist may enlarge a photograph to a huge size and thereby produce an image completely unlike that of the original object. Léger tells of an amusing experiment that he conducted. He took a picture of a fingernail and then proceeded to enlarge it one hundred times. The viewers to whom he showed it thought that they recognized the surface of some planet. With all the gusto of a magician explaining his tricks, Léger set them straight![16]

But the real magician who presided over the dramatic changes in our ways of seeing was, of course, modern technology, and it affords Léger, as he believes, emancipation from

that bondage to the subject that afflicted the art of Greece and the Renaissance. This conviction forms the background to the consistently 'mechanical' features of his paintings. And it helped to convince him that any object whatever, natural or man-made, offered resources for the plastic forms of his pictures and that, furthermore, no object was in this respect superior to another. Consequently, the human form, so beloved by the Greek heritage, became one among other forms – no better than they and no worse – all of them available to the artist for his use. (Fig. 16.) In Léger's judgement, nothing on earth possessed greater potential plastic value than anything else. Everything equally was grist for the artist's mill. Therefore, Léger could write: 'It has never been a matter, in a work of art, of copying nature. It is a matter of finding an equivalent for nature, that is, capturing simultaneously within the frame life movement, and a harmony created by assembling lines, colors, and forms, independent of *representation*'. 'One then understands that everything is of equal interest, that the human face or the human body is of no weightier plastic interest than a tree, a plant, a piece of rock, or a pile of rope'.[17] Léger once began an essay with the title, 'How I Conceive of the Figure', by saying that it 'could just as well have been called "The Bunch of Keys in Léger's Work" or perhaps "The Bicycle in Léger's Work". This means', he added, 'that for me the human body is no more important than keys or velocipedes. It's true. For me, these are plastically valuable objects to make use of as I choose'.[18]

This thinking of Léger informs not only his own paintings but also those of his Cubist colleagues, Pablo Picasso and Juan Gris. (Fig. 17.) To these artists and others of like mind, their pictures thus achieve not only liberation from outmoded canons but also their own integrity as objects, to be judged and valued in and for themselves, on their own terms, not upon the terms of some extrinsic and adventitious standard, like fidelity to natural forms. If this art will tolerate no imperialism, so it aspires to none. I make this judgement fully recalling what I said of Léger in an earlier chapter and I make it because I do not believe for one moment that his views on the reformation of society have anything decisive to do with his artistic theories, to say nothing of his achievement as an artist. The painter takes quite gladly the materials that nature provides him and without subservience to that nature he uses them for the creation of his own art. In his own mind, however, he is not swept up into an ideological dogma that would turn around and impose upon the natural realm or upon culture the quasi-scientific conclusions achieved by art. Even in the case of Léger, the husk is paper-thin, and for Picasso and Gris it seems not even to exist.

After all, ideology would endanger the very independence of art, for which these men fought. And it has not gone unnoticed that their demand for integrity is in principle – and whether they recognized it as such or not – a demand for that first condition of beauty laid down by Thomas Aquinas. Daniel-Henry Kahnweiler, for long a friend and champion of the Cubists, writes:

> In affirming the autonomy of the work of art, Cubists – unbeknownst to
> themselves, of course – were ambitioning for it that *integritas* which, according to

St. Thomas Aquinas, is required before anything else *ad pulchritudinem*. The pictures they created had to be 'individuals', this term being taken in the precise sense of: an organized being that cannot be divided without ceasing to be the same person, each one of these 'persons' having its own unique 'personality' and occupying its own place in history.[19]

From this vision there emerges integrity for the painting, of course, but as well, integrity for that nature with which in this chapter we are concerned. It is not exploited; it is not violated. Subdued it may be, used, yes, as a prolific source from which the artist may draw varied forms to employ for his own purposes. Surely God meant the creation to supply man in this way. And these men, in their art, at any rate, have not laid violent hands upon the resources that their Maker has provided. They have used them 'fittingly' in their efforts to add to our world objects whose beauty I, at any rate, see no need to defend.

I should like now to speak briefly of two artists whose work betrays an unusually close bond with the natural order. Such a union is all the rarer in our own day, pre-occupied as we are with the mechanics of cultural manipulation on the one hand and with the travail of our own psyches on the other hand. The art of our time reflects these pre-occupations, but occasionally a painter or a sculptor will come along to remind us that, as human beings, we are imbedded in a larger creation, and they explore for us the significance of these, our roots. The first artist I have in mind is, again, Henry Moore, whom we have already regarded from a rather different angle. Returning to him now, let us first remind ourselves of his insistence that the work of art should exhibit power above all else, a power resident in the natural world and therefore in man himself as an integral part of that world. We might wish to speak of him as a 'romantic' but we should have to use the term in a qualified manner, for there is little if any sentiment in Moore's view of nature and of man's relationship to it. If nature nourishes him it also threatens him, for its power can be terrifying and overwhelm all his tidy controls. So also, it goes without saying, can the nature within him. There appears in Moore's work a persistently disturbing element, of which he is entirely conscious.

The danger to man does not induce Moore to erect barricades against nature's incursions. That would be a futile gesture, a blind denial of man's own natural being. Rather, his sculpture explores and lays bare the character of that very being, 'expressed', as one critic has said, 'with an easy, natural, monumental grandeur and sometimes in a disturbing repertory of elemental forms dredged up from the depths of the subconscious'.[20] His reclining figures, his mothers and children, never lose their humanist content, but they 'mix' (as it were) with the creation, the quarry out of which they are dug. (Fig. 18.) Of one of his two-piece figures Moore has said just that: It is 'a mixture of the human figure and landscape . . . a metaphor of the human relation with the earth'.[21] This sculpture recalls us, children of an urban society, to our origins in nature, fearful though they may be; and it comes to direct grip with the power encountered there, subduing it by the imposition of artistic form.

The second artist I wish to mention is the American painter, Georgia O'Keeffe. About all of her paintings, whatever their subject, there is a certain smell of earth. Perhaps it reflects her origin in a small prairie village in the Midwest. Be that as it may, she approaches nature with an intent desire to simplify, one might even say to purify, its forms. A great clarity pervades her art and it never disappears, whether she is rendering a landscape or a flower. And this brightness results in a kind of penetration of nature that is as beautiful as it is unblinking. (Fig. 19–20.) In a series of flower paintings that she executed in the 1920's she moves by careful steps into the very interior of these blossoms and painstakingly draws us with her to reveal through a shining distinctness, the depths hidden there. We instantly feel delighted and 'at home'. Or a landscape may reveal human contours, which resembles nothing so much as a recumbent nude, the brilliant light playing upon its flanks, illumining a world in which mystery gives way to pleasure. O'Keeffe's nature does not brood; it is neither sombre nor awesome. It exists for human enjoyment and for ordinary human use, as a painting of a church in New Mexico may suggest. The church is constructed of adobe, mud and straw, simple materials of the earth, simply announcing the goodness of created things. Man may explore this world and enjoy it without anxiety. It will meet all his needs, for it is, after all, *his* home. And what else, indeed, did God intend his creation to be? In the artist's vision it has become that satisfying, sparkling, and well-ordered place.

A kindred vision of even greater range and subtlety belonged to the painter who, it seems to me (if I may make my bias plain), was the greatest artist of our century – Henri Matisse. Of himself, he once said, in a statement that since has become famous, 'What I dream of is an art of balance, of purity and serenity, devoid of troubling or depressing subject matter, an art which could be for every mental worker, for the business-man as well as the man of letters, for example, a soothing, calming influence on the mind, something like a good armchair which provides relaxation from physical fatigue'.[22] A straightforward, simple dream; but not an easy one to realize. For the creation of his 'comfortable' art, Matisse, throughout his career, steadily and consciously preserved an open relationship to nature. He freely criticized those who, as he put it, copy nature 'stupidly', the Academicians, for whom art was imitation. Matisse's own approach to nature was far subtler and far more fruitful. In 1908 he wrote: 'An artist must recognize, when he is reasoning, that his picture is an artifice; but when he is painting, he should feel that he has copied nature. And even when he departs from nature, he must do it with the conviction that it is only to interpret her more fully.'[23] Perhaps the key to his method lies in a word that he frequently used, the word 'sensation'. It was the sensation he wished to grasp, the sensation that perceiving nature aroused in him, and it was this sensation that he strove to present on canvas. But he had to take care that the feelings he expressed were not of fleeting nature; in order to satisfy, they had to be more lasting. He therefore speaks of 'condensing' his feelings in a painting and making it thereby a genuine representative of his state of mind.[24] A painting, he considered, was only finished when he had emptied

into it the entire content of the emotion that he wished to express. Then he felt released, sunk, one might say, into that good armchair of which he himself spoke.

As I have said, it was his confrontation with nature that generated in Matisse these sensations, and to nature he constantly turned for the fresh nourishment required for his work as an artist. This procedure differentiates him, as he perfectly well knew, from the Cubists. 'For me', he noted, 'it is the sensation first, then the idea. I see a bouquet of flowers, it pleases me. I do something. If the Cubist conceives an idea and then asks himself "what sensation does that give me"? – 'well, I just don't understand that.'[25] Again: 'One starts off with an object. Sensation follows. One doesn't start from a void. Nothing is gratuitous.' The Cubist, it may be, is like Kierkegaard's autodidact, spinning beautiful thoughts out of his own mind. But Matisse looks outside himself and finds in the perception of nature the place where his art begins.

Matisse's reformulation of nature can best be understood, if we are able to grasp his pictorial treatment of space and time, those two agents that frame our existence. Here, I propose to concentrate upon space and in the next lecture to offer some comments upon time. There occurred in 1911 a decisive turn in Matisse's art, the beginning of an experimental period that lasted until 1917. During those years he explored in a succession of large paintings the possibility of depicting a 'space which is at once descriptive of tangible objects and at the same time pictorially intangible or flat'.[26] In early 1911 he completed a version of 'The Painter's Studio'. It preserves a marked element of aerial perspective, the illusion of three dimensions, achieved by the contrast between floor and background wall, which, in turn, defines the space within which the objects in the studio are deployed. At the same time, however, it is equally evident that the third dimension of depth has undergone a certain flattening. The rug on the left has been tilted downward, as has the top of the small table on the right. Matisse carried this process to an extreme in another painting, the so-called 'Red Studio' of the same year. (Fig. 21.) Now wall and floor alike are painted monochromatic red, with the 'break' between them suggested only by the outlines of the objects, some 'standing' on the floor, while others as well 'rest' against the wall. The paintings in the studio seem at once to occupy their allotted space and to leap from the uniform red background. It is not only possible but necessary to read them both ways. Late in 1911 Matisse carried still further his experiments with space in 'The Blue Window'. (Frontispiece.) The flattening again is pronounced and is due in part to the pervasive blue colour. It is reinforced by the alignment of the table top with the window, and the outdoor space has entered the room, as trees spring from vases and the top of a sculpted head. 'Matisse . . . not only plucks a green vase from a yellow pin-cushion but provides it with ornaments by means of thin black hatpins'.[27] Clearly, Matisse was human enough to indulge his whimsy, and we, I hope, are human enough to enjoy it! The vase and the pincushion, however, illustrate the artist's reconstruction of space. As one critic says,

Although they are in the same area as, and are thereby read as being with, the objects on the table, they are in fact not on the table, but 'on the wall'. The objects, if one were to read them literally, thus perform an impossible action: they defy gravity and float in space. In fact, of course, the viewer does not read the objects as floating, but because of the dense and poetic space, accepts the ambiguity of the placement and relative plasticity of objects in the same way that the reduction of the trees into circular forms and of the cloud into an ellipse, is accepted; the same way that the space outside the window and inside the window is accepted as paradoxically united on the same plane.[28]

Throughout most of the 1920's Matisse lived in Nice. It was a happy and relaxed time for the artist, as the pictures that he painted show. (Fig. 22.) But they also reveal his marked preoccupation with the rendering of space, a preoccupation now more tranquil, less strenuous. They are also characterized by scenes viewed through a window, but they now possess a bright charm quite unlike 'The Blue Window' of 1911. When asked some years later what accounted for the charm of these pictures, Matisse once more appealed to space, the space which, he said, 'is one unity from horizon right to the interior of my work room, and . . . the boat which is going past exists in the same space as the familiar objects around me; and the wall with the window does not create two different worlds'.[29] Much later, toward the end of his life, Matisse decorated the interior of The Chapel of the Rosary at Vence. In this work he declared it his intention to create 'the idea of vastness which touches the soul and even the senses'. It is painting's task 'to enlarge surfaces, to work so that one no longer feels the dimensions of the wall'.[30] Thus he renews and re-creates the space that he encounters in nature.

Making the same point in another way, Matisse spoke of the 'possession' of space. It is a demand of the age, he thought, an age in which the airplane has drawn back the curtain of space and revealed its vastness. One wishes that Matisse had lived until the day when men landed on the moon. But, while most of us will not soon put in an appearance on the moon, I suggest that this artist presents us with a new and compelling vision of space, one of God's most mysterious and fascinating creatures. He accomplishes this 'new creation' by the fusion in his paintings of the space he *perc*eives in nature and the space he *conc*eives in his own mind.[31] I can think of no better illustration of his effort to condense sensation and to express it in pictorial form.

Now I must add a final word concerning Matisse's possession of nature, for it is his own final word on the subject. This fresh penetration of reality can be achieved only upon condition that the artist approach nature with a sincere, humble, and loving mind. 'Nothing', he wrote in a manifest echo of St. Paul, 'is more gentle than love, nothing stronger, nothing higher, nothing larger, nothing more pleasant, nothing more complete, nothing better – in heaven or on earth – because love is born of God and cannot rest other than in God, above all living beings. He who loves, flies, runs, and rejoices; he is free and

nothing holds him back.'[32] So, it is necessary that the artist preserve the innocent eyes of a child, who in wonder and love receives the world's myriad treasures. His work, Matisse believes, 'will then appear as fertile and as possessed of the same power to thrill, the same resplendent beauty as we find in works of nature'.[33]

Karl Barth once declared that the music of Mozart led him 'to the threshold of a world which is good and well ordered, in sunshine and thunderstorm, by day and by night'.[34] It suggested to Barth a parable of God's Kingdom, and that is what Matisse's art suggests to me. Parables are not themselves the reality alongside which they are 'thrown'. But they point toward that reality and, more, they anticipate it. Now the artist builds images of a world that he foresees. When they are endowed with the 'resplendent beauty' displayed in Matisse's paintings, so sensitively wrought from the subdual of this present nature, they afford us glimpses of what this nature shall become, when he, who in the beginning created it, brings it to that fulfilment and re-creation, which he has himself promised.

NOTES TO CHAPTER 5

1. Calvin, II. ii. 14, 16.
2. William Butler Yeats, 'Sailing to Byzantium,' Verse IV, from *The Collected Poems of W. B. Yeats* (New York: The Macmillan Co., 1959), 192.
3. Will Grohmann, *Paul Klee* (New York: Harry N. Abrams, Inc., n.d.), 97.
4. Cassirer, 164.
5. Quoted in Joop Joosten, 'Mondrian: Between Cubism and Abstraction', in *Piet Mondrian: Centennial Exhibition* (New York: The Solomon R. Guggenheim Foundation, 1971), 61.
6. Quoted in F. David Martin, *Art and Religious Experience: The 'Language' of the Sacred* (Lewisburg: Bucknell University Press, 1972), 154.
7. Rosenberg, 34.
8. Bann, xix.
9. Cf. Michel Seuphor, 'In Defense of an Architecture', quoted in *ibid.*, 183.
10. *Ibid.*, 193.
11. *Ibid.*, 206.
12. Cf. Charles Biederman, *Art as the Evolution of Visual Knowledge*, quoted in *ibid.*, 225ff.
13. *Ibid.*, 226.
14. Ernst Cassirer, *The Logic of the Humanities* (New Haven: Yale University Press, 1961), 189.
15. Léger, 57.
16. *Ibid.*, 48f.
17. *Ibid.*, 91f., 111.
18. *Ibid.*, 154.
19. Quoted in Gilson, 191, n. 23.

20. James, 14.
21. *Ibid.*, 271.
22. Flam, 38.
23. *Ibid.*, 39.
24. *Ibid.*, 36.
25. *Ibid.*, 123.
26. *Ibid.*, 12.
27. Alfred H. Barr, Jr., *Matisse: His Art and His Public* (New York: The Museum of Modern Art, 1966), 166.
28. Flam, 13f.
29, *Ibid.*, 93.
30. *Ibid.*, 139.
31. *Ibid.*, 13.
32. *Ibid.*, 113.
33. *Ibid.*, 149.
34. Karl Barth, 'Wolfgang Amadeus Mozart', *Religion and Culture: Essays in Honor of Paul Tillich*, Walter Leibrecht (ed.) (New York: Harper and Brothers, 1959), 63.

Chapter 6

Human Response to Art

Orthodox Protestantism has not been artistic in the direction of painting. It has had, through Calvin, the French and Greek tendency to intellect and the Greek insensibility to the warm and coloured side of life, as well as the civic and social instinct of Greece. Through Calvin it followed the modern scientific tendency to construe the world rather than represent it; while through Luther and Teutonism it had a bias to the homely, and a grasp, often gross, of the obtrusive realisms of life, as well as a prior bias to music, where Protestantism has been inward and spiritual with the best. But still more, it has had to contend for the primacy of the ethical in life and salvation. It has been too engrossed with the moral conflict of life, with sin, and the escape from it by inward victory, to have its interest free to devote to the lines of beauty and the glow of colour.[1]

I AM NOT SURE whether orthodox Protestants (to say nothing of the French and the Greeks) would endorse that statement, but it is P. T. Forsyth's way of explaining Protestantism's general lack of interest in painting and sculpture, both in the making of them and in the appreciation of them. At any rate, it is perfectly true that the main line of Protestant thought has implied, if not affirmed, a rather weak assessment of the value of art within the religious, if not also the entire human, enterprise. We may recall Calvin's remark that images could be divided into two classes: those that depict historical events and those that depict the forms of bodies, without reference to any narrative. Calvin then proceeds to observe, 'The former have some use in teaching or admonition; as for the latter, I do not see what they can afford other than pleasure'.[2] What in fact art affords us men and women – that is one way to regard the theme of the present chapter. And even if Calvin would say, 'not much', his statement still gives us a starting point for our own thinking on this subject. He speaks of art's value in teaching – in education, that is – and in providing pleasure. I want to consider both those alternatives, though I shall take them up in reverse order, pleasure first and, subsequently, education. I then intend to discuss two other responses that art may evoke from us – contemplation and what I should call re-creation. For the most part, I intend to consider the standpoint of the viewer of art, not that of the artist. For this reason, the title of the chapter is 'Human Response to Art'.

From the context of his statement, one can tell that Calvin judges the pleasure derived

from art to be a rather small reward. I do not myself agree that we should deprecate those things that give us pleasure, the less so if we consider them God's gifts, which I take painting and sculpture to be. Aiming to please has long been a prime purpose of the artist, and the best artists have achieved it with great success. Stuart Davis, of whom I wrote in an earlier chapter, once declared, '[The artist] keeps alive one of the important faculties of man by cultivating it, and, by his work, continues to give objective proof day by day of the possibility of enjoyment of the form and color of our environment'.[3] This power to delight is not limited of course to the visual arts. It inheres as well in, for example, poetry. Take this description, from a novel:

Presently Aziz chaffed him, also the servants, and then began quoting poetry, Persian, Urdu, a little Arabic. His memory was good, and for so young a man he had read largely; the themes he preferred were the decay of Islam and the brevity of Love. They listened delighted, for they took the public view of poetry, not the private which obtains in England. It never bored them to hear words, words; they breathed them with the cool night air, never stopping to analyse; the name of the poet, Hafiz, Hali, Iqbal, was sufficient guarantee.[4]

In that segment from *A Passage to India* Forster portrays the immediacy and the intensity of the pleasure derived from poetry, almost an intoxication. The listener or, may be, the reader (but preferably the former, I should say) abandons himself to the words, not stopping to question or analyse the effect that they produce upon him, but just simply enjoying them.

Now, to transpose these observations from poetry to the visual arts, consider Renoir's famous canvas, 'The Luncheon of the Boating Party'. (Fig. 23.) If a single painting sums up the joy of the Impressionist vision this is the painting. It is a masterpiece of masterpieces for the very reason that its lines, forms, and colours evoke such unmitigated pleasure when we view it. It has been called 'more immediate . . . than most of our actual experience. Perhaps more fully than if he had been the Impressionists' guest that afternoon, [the spectator] responds to a wondrously sensuous blend of the warmth and delight of nature and human communication . . . it is somehow more than a painting: it is also a poem, a song, a celebration; a memory, valid for all time, of every golden convivial afternoon, of all lovable women and virile men; of the caress of unpolluted air upon the cheek, of the bouquet of wild flowers, of the murmur of voices over water, of all the ecstasies of summer.'[5]

This painting fulfils to perfection the definition of a beautiful object – 'that which pleases the eye'. To grasp it as such, however, requires on our part an act of humility, almost of abandonment. We must submit ourselves to the picture, for only upon that condition shall we enjoy the delight that it offers. And I should not myself be inclined to apologize for such submission. I have already suggested that we ought not to deprecate that which pleases us. And I here add that I consider such a beautiful object to be, indeed, a gift of God, designed for the enrichment of our lives. To ignore it would be negligent

of us, evidence that we failed to appreciate not merely the painting but also the generosity of the Lord, who furnishes us with such good gifts as this. By the same token, of course, to worship such a painting would be idolatrous. The gifts of God are one thing; God himself another. If we confuse them we should suffer from that disordered love, about which Augustine wrote and about which I have already said enough. Some while ago, I discovered in the home of a friend a painting by Paul Klee. It was a charming bit of virtuosity, and I congratulated my friend on having it. 'Yes', he said, 'when I look at it, it makes me happy'. And so it should. And he might have added (though he did not), 'Thank God'. Like all of his gifts, beautiful pictures are something to cherish, and the pleasure we derive from them nothing to despise.

Besides pleasing us, art, as Calvin noted, may also serve to educate us. Seeing it, we may 'see' more than we previously did. It may open the mind's eye to vistas not previously glimpsed. Calvin was thinking, of course, of narrative painting, painting that depicts historical events, and no doubt he meant chiefly episodes from the Bible. On this matter, I confess that Calvin seems to me much wiser than we are. At least that is in principle the case, to judge by the quality of the reproductions that litter the classes of our churches' schools. This art is excessively sentimental and trivial, and it may very well constitute the 'fate' of Protestantism for its long neglect of the visual arts.

For education to advance, some communication must occur, some human communication. Concerning such a possibility, artists have been now sanguine, now pessimistic. The avowed aim of Lucretius, in his *De Rerum Natura*, was to teach the Epicurean philosophy that he espoused. His success in communicating it depended upon the quality of his poetry, whose beauty I accept upon the judgement of Latinists far more accomplished than I. And yet the art may stand in the way of the communication, for the learner may simply halt, entranced by the pleasure that it gives him, and never proceed to the more serious matters that the artist intends to communicate. It was for some such reason as this, I suppose, that Calvin suspected the value of 'mere' pleasure. It is all too easy to lick the sugar coating without ever swallowing the pill!

And, indeed, the pill may not be worth swallowing. Wassily Kandinsky was a painter who believed his art to be the expression of cosmic laws and who formulated this conviction in a book entitled *Concerning the Spiritual in Art and Painting in Particular*. (Fig. 24.) Kandinsky knew quite well that colour in pictures may give pleasure, but he regarded this, he writes, as a 'superficial impression'.[6] His more ambitious aim was to arouse in the viewer a second, deeper impression, constituted by more complex feelings. 'It is evident therefore', he continues, 'that color harmony must rest ultimately on purposive playing upon the human soul; this is one of the guiding principles of internal necessity'.[7] The harmony of forms rests upon the same foundation and is another 'principle of internal necessity'. Precisely the same may be said of the painter's choice of an object. Kandinsky, who is often hailed as the originator of non-objective art, was convinced that 'the freer the abstract form the purer and more primitive the vibration' in the soul of the painter

and that, furthermore, the painting would set up a resonant vibration in the soul of the spectator. Thus Kandinsky believed firmly that his art, provided that he attended carefully to the inner laws of his own spirit and the means for expressing them, would infallibly communicate with the spectator, whose spirit, of course, was subject to the same laws. I hope that I have not offered a caricature of Kandinsky's position and I ought to add that he acknowledged that the feelings with which he was concerned – joy, grief, and so forth – were general and imprecise in nature, whereas 'Shades of color, like those of sound, are of a much finer texture and awaken in the soul emotions too fine to be expressed in prose'.[8]

For myself, I confess that I think Kandinsky expressed himself much better with colour than with words and I would far rather look at one of his canvases than read one hundred pages of his prose. I do not find that my own soul 'vibrates' in quite the fashion that Kandinsky maintained and so, to him, I am probably a poor learner who has failed to receive the communication that he intended in his art. But I take some solace from the remark of one of his chief admirers, Ms. Hilla Rebay, who for years was adviser on matters artistic to Mr. Solomon R. Guggenheim, whose museum in New York bears his name. Ms. Rebay observed of Kandinsky's (and other artists') abstract works: 'The contempla-tion of a Non-objective picture offers a complete rest to the mind. It is particularly beneficial to business men, as it carries them away from the tiresome rush of earth, and strengthens their nerves, once they are familiar with this real art. If they lift their eyes to these pictures in a tired moment, their attention will be absorbed in a joyful way, thus resting their minds from earthly troubles and thoughts'.[9] I am sure Kandinsky had in mind something more profound than the relaxation of tired business men, as if his paintings afforded a sort of aesthetic steam bath! But *what* he had in mind is so elusive and nebulous that it passes right through all the sieves in my own brain.

I have already said that I do not deprecate the pleasure that art provides, either to tired business men or to anyone else. Nor do I wish to deprecate the educational intent of artists. But it is very difficult to fulfil. After all, artists are makers, not thinkers. They are not 'idea men'; their talent is of a different order, as some of them, like Willem de Kooning, clearly recognize. He once said, quite sourly, that artists do not have very good ideas. The declaration is too apodictic, of course, but it is a point to keep in mind, as we consider, as I should now like to do, works by two different artists and the effort to communicate that informs them.

Consider first Hans Hofmann, an émigré from Germany to the United States and a senior member of the loosely affiliated group designated Action Painters. One may glean pleasure from his abstract forms, with their stunning colours, and enjoy his pictures as objects that please the eye. But the painter has more in mind, as is evident from the title of one of them – 'Memoria in Aeternum'. (Fig. 25.) (Let me add in passing that we should beware being gratuitous about the titles that artists attach to their works. They are often of enormous help. Especially in the case of an abstract painting, such as this one, they assist

us in the understanding of it and guide our minds into the intention of the artist, so that genuine communication does occur.) Concerning this painting, we know as well that Hofmann designed it as a memorial to five dead artists whose work he admired. It is a memorial, 'in aeternum', to these colleagues and it has been described as follows:

> An area covering almost the whole of the large canvas is brushed in a cloudy brownish mixture streaked with red, yellow and blue, like waste paint on a palette (the abandoned painting tables of the dead artists?) or like a wall of earth seen up close. Upon this wall two vertical rectangular planes, one a scarred red about twice the size of the other, create a pictorial breathing space by their different suggestions of depth, while as panels they invite memorial inscriptions. The impression of being inside the earth is heightened by an upward movement toward the domelike mass that crowns the composition and which is flanked on each side by blues of flowers and the sky. But the brooding earth wall is changed into a lifting veil by a small edge of brightness that is as if torn out of the lower left-hand corner of the canvas. I cannot think of another painting that intimates immortal hopes by such strictly abstract means.[10]

What the painting communicates to us is not a philosophy (Epicurean or any other), but a feeling, a hope, an intimation of life in, through, or beyond the grave, restricted, I should say, not to the ongoing life of these men's art but encompassing as well themselves, the persons, and the longing that they should themselves share in a life everlasting. A painting like this continues to lay bare for us the indefectible yearnings of human hearts and to remind us that the treasure of the gospel, when *we* can communicate *it*, *is* good news to a world of mortal cares and death.

My second illustration is drawn from Naum Gabo, the great Constructivist sculptor, who has written very movingly about the intention of his own art. Gabo shares a viewpoint similar to Kandinsky's in believing that the elements of visual art should reflect universal laws and that they 'possess their own forces of expression independent of any association with the external aspects of the world; that their life and their action are self-conditioned psychological phenomena rooted in human nature ... immediately and organically bound up with human emotion'.[11] Laws or no laws, Gabo continues by affirming his conviction that art is 'the most immediate and most effective of all means of communication between human beings'. And what is he trying to communicate by his own sculptures? He tells us: 'I think that the image they invoke is the image of good – not of evil; the image of order – not of chaos; the image of life – not of death. And that is all the content of my constructions amounts to. . . . I am offering in my art what comfort I can to alleviate the pains and convulsions of our time. I try to keep our despair from assuming such proportions that nothing will remain in our devastated life to prompt us to live'.[12] If Gabo is justified in his claim (and I believe that he is), then art indeed becomes a good gift of God, a blessing born of man's natural endowments to erect dykes of order against the chaos that forever threatens to engulf him. It serves to establish that time and that space

in which the Lord's work may go forward. Without it creation would surrender to chaos and Yeats's 'mere anarchy' be loosed upon the world.

Some persons who have reflected upon art insist that one prime human response to it is that of contemplation. Not everybody agrees with this view, and among its opponents, evidently, was the American architect, Frank Lloyd Wright, who designed the interior of the Guggenheim Museum with one continuous, descending circular ramp. As a consequence, the observer of the art perforce stands slightly tilted. A prominent critic complained that, tipped in such fashion, one could not properly contemplate the works. And it is perfectly true that Wright's inclined plane exercises a constant, if slight, impulsion to keep the viewer moving. Undoubtedly the effect was intended; Wright did not approve of contemplation before a work of art.[13] But others do. I call to mind the famous tale of the Chinese painter, who, having finished a landscape, found it so beguiling that he simply stepped into it, there to take his place in contemplation of the world that he had himself created!

I expect that the Chinese painter would find sympathetic support from a contemporary scholar like Étienne Gilson, who declared, 'There is nothing that one can do *with* a painting. . . . If he consideres a painting as a means to any other end than its contemplation, a man does not see it as a work of art.'[14] Gilson sets much store by the immobility of the painting itself, statically occupying a given space and presenting itself as a whole, at a single time, in distinction from a piece of music, which unfolds over a span of time. Because of its special character, Gilson argues that the perfect subject of painting is still life, 'which, by definition, is a picture consisting of inanimate objects. . . . In a still life nothing acts, nothing gesticulates, nothing does anything else than to be. . . . The kind of plenary satisfaction we experience while looking at a still life is due to the perfect adequacy that obtains, in this case, between the substance of the work of art and the reality that it represents'.[15]

While Gilson finds still lifes most conducive to contemplation, others would favour abstractions. One scholar, F. David Martin, has recently hailed abstract paintings for just this efficacy. He observes that in the case of a picture representing concrete objects time and space remain 'relevant associations'.[16] Not so with abstractions. If, as Martin says, we do not simply view them but actually participate in them, they deliver us from every specific time and space. We lose our self-consciousness and pass into an immobile and changeless realm whose quality resembles the very eternity of Being. 'This encompassing emptiness', he writes, 'that permanently "is" makes abstractions especially appealing to mystics. . . . And that is why abstractions, even the frenzied works of some of the abstract expressionists, are calming. Nothing is so likely to save us from the slavery of functions as abstractions'.[17]

To be quite candid, I am no mystic and I find it difficult to summon any sympathy for the views expressed by Gilson and Martin. I shall try, however, not to let my bias warp my criticism, but, in all fairness, I should mention it. The contemplative response to art,

however, seems to me misguided on several counts. In the first place, it does injustice to the works themselves. To support his judgement of still lifes, Gilson would have to be very careful in the selection of the paintings. Maybe, just maybe, one might derive from a still life by Chardin the 'plenary satisfaction' of which he writes. But a still life by Soutine evokes a very different response and scarcely promotes the contemplative calm and quiet that so appeal to Gilson. One might also note that, while it is true in a still life that 'nothing … does anything else than to be', it is equally the case that nothing does anything else than to be – dead! And it strikes me that Gilson's vision of our response to still life is itself deadening. When he writes of abstractions, Martin apparently takes them to be portals through which the participant passes into the fields of a timeless contemplation, undisturbed even by self-consciousness. I doubt that most artists intend that their pictures be used in this manner, as instruments to employ and discard. Such a response violates what has been called the artist's love of the particular. Martin goes so far as to chide Jean Arp for entitling a work 'Mountain, Table, Anchors, Navel'. (Fig. 26.) The title, with its concrete references, inhibits the value of the work as an aid to contemplation. This preposterous criticism of Arp only demonstrates that Martin does not see the painting for what it is – a remarkable combination (even a blend) of the concrete and the abstract, rendered with matchless humour and verve. Arp offers us the work – *and* the title, a communication both visual and verbal. It is gratuitous to accept one without the other.

In the second place, contemplation, as a response to art, suggests to me a certain misuse of these gifts of God. I do not believe God means them as agents to lift us out of our created time and space. This criticism is tricky and complex. Theologically, I should base it upon the doctrine of the incarnation, the conviction that in Jesus Christ God shares and thus hallows our own time and space. The effort to escape from them implies ingratitude even for this, God's most precious gift. It reminds me of Karl Barth's warning that, in trying to ascend to God, we may simply hurry past him as he descends to us. On the other hand, we must take due account of the way in which Jesus Christ *does* re-create our time and space. (This problem is part of a larger one, namely, how it is we regard Jesus Christ as, on the one hand, the particular individual person, Jesus, and, on the other hand, the universal Lord of all.) At any rate, the doctrine of the person of Christ should lead us neither to dismiss the particularity of a work of art (in the manner of Gilson and Martin) nor to overlook its power to re-create our own specific existence. So far as time and space are concerned, I have had occasion to consider the latter. I should now like to offer some reflections on time, from the standpoint of the person who looks at a work of art.

One finds in seventeenth-century Dutch painting, for example, a narrative device which by that date was already commonplace in art. Within the space of one canvas the painter depicts a series of discrete times, such as the episodes in the parable of the Good Samaritan. (Fig. 27.) The Samaritan himself is bending over the wounded man. Those who passed by are walking away to the left. And in the far left distance one can glimpse the Samaritan entrusting the man to the care of the innkeeper. The single painting displays

various times, but they do not, as it were, 'overlap'; they maintain their sequential charac-
ter, even though they have all been presented within the scope of this single composition.
The picture thereby invites the viewer to follow in his own mind the progression of the
narrative, step by step, to retrace it, if he wishes, to pause here or there, and, finally, to
grasp mentally the entire content of the parable.

Some paintings, instead of explicitly portraying various times will suggest them. As
an example, we may take the celebrated 'Avignon Pietà' from the Louvre. Mary, with
the dead Christ in her lap, occupies the centre of the picture. They are flanked by St.
John on the left and the Magdalen on the right. But the most arresting figure in the
painting is the donor, who kneels at the lower left. As for the space he occupies, it is
uncannily both *in* the composition and yet *outside* it; he is at once part of the painting's
subject, while also a viewer of the scene. Yet he is not looking at the dead Saviour. He
is turned, instead, half toward the viewer. We may see clearly the expression on his face,
and it tells us that he has *already* looked upon Jesus.[18] He is contemplating, but his con-
templation is one not only of peace, but also of full consciousness. He remains a fully
particular person, who always reminds me of Simeon, who, having seen the Lord's
salvation, was able to depart in peace. As a whole, the painting is a masterful portrayal
of that mysterious unity between eternity and time, accomplished in the person and work
of Jesus Christ, a unity into which we, like the donor of the 'Avignon Pietà', may be
incorporated, not to the loss of our selves but to our fulfilment. Our time ceases to be
'one damned thing after another'; it is elevated, condensed (to use Matisse's term for the
space in his pictures), redeemed.

The distinction formulated by Lessing in his *Laocoön* between arts of time (such as
music) and those of space (such as painting) is one pursued by Gilson, and with much
justification. A picture does present itself, entire, in a given space. Moreover, its figures are
'frozen'; they do not literally move, and, in Gilson's opinion, nothing would be gained by
setting them in motion, were such an act possible. But two qualifications should be ob-
served. The first is that often a painter means to suggest motion to *us*, the viewers of his
work. Consider another painting by Renoir, his 'Bal à Bougival'. (Fig. 28.) The couple
are caught at a single instant in their dance, and, while of course they do not move around
on the canvas, their pose insistently implies motion to us as we look at them. And we
have the feeling that, if we turned our backs, they might indeed dance away, poised as
they are upon the brink of their next step. Abstract painting may convey much the same
feeling. To Kandinsky, motion was itself an element in painting. It has been said of his
pictures: 'Sometimes a series of points, traces like trajectories or orbits describe this
movement; often an unbalance of tension between the forms demonstrates the motion'.
But he never indulges in movement for its own sake, sheer virtuosity. 'There even seems
to be a deepening sobriety ... a greater restraint – the use of extremely stable, static
constructions in which one or a few elements of varying tension indicate motion or
the drift of the space through the construction'.[19] Again, of course, the forms do not

literally move. It is our minds that set them in motion. Thus they assume, for us, a mobile and hence temporal character. And that is just what the artist intends – to draw us into a world with its own special time, a segment delimited by the lines, forms, and colours on the canvas, all combined to produce their own special rhythms. Contemplate such a painting we may, to be sure, but if the contemplation is characterized by peacefulness it is by no means still. It is restful, but mobile and thoroughly conscious.

For the second qualification of Gilson's view we turn to sculpture. A piece of sculpture is as static as a painting, but it is more difficult to approach because it possesses three dimensions rather than two. Therefore, in order to grasp it, we have ourselves to move; we cannot remain still before it. If *it* is not ambulatory, *we* are, and, as Henry Moore has written, 'Sculpture is like a journey. You have a different view as you return. The three-dimensional world is full of surprises in a way that a two-dimensional world could never be. . . '.[20] As we move around a piece of sculpture we remember impressions of it just past until at length we have regarded it from every angle and compress in our own minds the various feelings it has evoked. We have gathered them one by one through a succession of times, but they exist together united and fused in our own imagination. Finally, the neat distinction between arts of time and of space is virtually destroyed in the case of sculpture that itself moves. A mobile by Alexander Calder simply is never entirely 'there' in a given space at a given moment. Certainly the amount of space that it occupies is restricted, if not definite. But the time over which it appears to us is almost limitless; it resembles a piece of music that goes on and on without exhausting all the possible combinations and changes through which it may pass.

But whatever the qualifications of Gilson's position, we are mainly concerned not with the time or times of the work of art as such, but rather with our own time as viewers of that work. And I reiterate what I mentioned earlier, namely that the use of a painting or of a piece of sculpture completely to deliver us from our temporality constitutes an abuse of the work, of God's gift. Even if such a use is possible, it is not permissible. And, in my judgement, sculpture virtually forbids it, since it demands movement from us. Moreover, it frequently betokens energy and struggle. As Henry Moore writes, 'All that is bursting with energy is disturbing – not perfect. It is the quality of life'. But time and struggle go together, as do timelessness and contemplation. Action Painting, as clearly as one of Moore's pieces, equally portrays a struggle and equally is not patient of a contemplative response. One might well ask, however, whether paintings of geometrical abstraction, like Mondrian's, do not promote contemplation. In a sense they do, but it is contemplation of a conscious sort. We may call Mondrian himself as a witness in favour of the argument. True, the static equilibrium that he achieved in his pictures does represent to him an ideal, a universal, that is the object of what he calls 'universal contemplation'. Furthermore, he was persuaded that the 'deepest purpose of painting has always been to give *concrete existence, through color and line, to this universal* which appears in contemplation'.[21] At the same time, it is also true that Mondrian constructed his lines and planes

through the most intense conscious concentration. He strove, as he says, to eliminate both chance and calculation from his work. And the person who beholds and surrenders himself to one of these paintings might, Mondrian believed, enter an elevated state of consciousness, might achieve an expansion of his intellect.

I do not wish to misrepresent Mondrian's own intention. It is possible to read some of his statements in such a way as to conclude that he meant his pictures to lead the viewer into an eternal stillness, broken by no shadow of turning. Yet I do not myself understand them to function in that manner. Sir Herbert Read says of him that he 'was trembling at the limits of a new dimension of consciousness'.[22] He was a pioneer in that struggle, through art, for ' "mental existence" '.[23] As one critic puts the matter: 'We feel ourselves in the presence of a larger struggle – indeed, a larger world – in which mind grapples with eternal threats to its fragmentation and dissolution'.[24] Through all of this, however, and regardless of whatever universal it expresses, a painting by Mondrian retains its own irreducible particularity. To lose that is to lose everything. These pictures exhibit in a way that one can scarcely explain that mysterious union between the concrete and the universal. It is impossible to have the latter without the former. We cannot do away with the form of the painting and greedily absorb (or be absorbed into) that essence which it embodies.

But embody it, it does. And the effect of great art, whether Mondrian's or another's, upon our time as viewers testifies to this achievement. They lead us to that mental compression of time past, time present, and time future, of which Augustine wrote in the tenth book of the *Confessions*. They do not invite us to strip away our temporality and our consciousness of time, to deny our creatureliness; but they *do* invite us to enter a certain fulness of time that adumbrates, I should say, the time of God's own Kingdom, in which the sheer succession of moments, the tyranny of time, loses its power.

The God who reveals himself in the person of Jesus Christ is not only pure act but, as well, individual act – *actus purus*, says Karl Barth, *et singularis*. The finest painting and sculpture, preserving both singular as well as universal character, reflect in their own fashion the being and purposes of this God, whose gifts they are. As such, they are, moreover, analogues of his good news, for, as the late American architect, Louis Kahn, insisted, 'The creation of art is not the fulfillment of a need but the creation of a need. The world never needed Beethoven's Fifth Symphony until he created it. Now we could not live without it.'[25] The world never needed – or at least did not know that it needed – Renoir's 'Luncheon of the Boating Party' or Matisse's 'The Blue Window' or Mondrian's 'Composition No. 2' until they were created, but now we could not get along without them. Like the gospel, they supply the very need that they create; like the gospel, art re-creates us in a fashion nothing else can duplicate. The supreme artists sense this remarkable power – and responsibility – that they possess. The words of Paul Klee, written first in his journal and later inscribed on his tombstone, may speak for them all: 'I cannot be understood in purely earthly terms. For I can live as happily with the dead as with the

unborn. Somewhat nearer to the heart of all creation than is usual. But still far from being near enough'.[26]

NOTES TO CHAPTER 6

1. Forsyth, 125f.
2. Calvin, I. xi. 12.
3. *Stuart Davis*, 100.
4. E. M. Forster, *A Passage to India* (New York: Harcourt, Brace & World, Inc., 1952), 15.
5. William Seitz, 'The Relevance of Impressionism,' *Art News*, Vol. 67, No. 9 (January, 1969), 31.
6. Wassily Kandinsky, *Concerning the Spiritual in Art and Painting in Particular* (New York: George Wittenborn, Inc., 1970), 43.
7. *Ibid.*, 45.
8. *Ibid.*, 63.
9. Quoted in Martin, 150.
10. Rosenberg, 204.
11. Quoted in Bann, 211.
12. Quoted in *ibid.*, 218, 220.
13. Rosenberg, 162.
14. Gilson, 118.
15. *Ibid.*, 26.
16. Martin, 159.
17. *Ibid.*, 157.
18. For this analysis of the 'Avignon Pietà' I am indebted to the late Marquand Professor of Art at Princeton University, Albert Mathias Friend, Jr.
19, Stanley William Hayter, 'The Language of Kandinsky', in Kandinsky, *op. cit.*, 17.
20. Quoted in James, 266.
21. Quoted in *Piet Mondrian: Centennial Exhibition* (New York: The Solomon R. Guggenheim Museum, 1971), 27.
22. Read, 133.
23. *Ibid.*, 17.
24. Hilton Kramer, 'Mondrian: He Perfected Not a Style but a Vision', *The New York Times*, February 24, 1974, Section D, 19.
25. Quoted in *The Exonian*, March 28, 1974, 1.
26. Quoted in Grohmann, 95.